From MacGuffin to Cliffhanger

25 Narrative tools
from a Screenwriter's Toolbox

DAVID ESTEBAN CUBERO

© David Esteban Cubero, 2024

© Guiones y guionistas, 2024

© 2024. All rights reserved. No part of this work may be reproduced, stored in a retrieval system, or transmitted in any form or by any means (electronic, digital, mechanical, photocopying, recording, or otherwise) without prior written permission from the copyright holders. Infringement of these rights may constitute an intellectual property offense. Specifications are subject to change without notice.

Cover: © David Esteban Cubero

Cover illustration: © Edu Sganga

Publisher Guiones y guionistas

cursosdeguion.com

Gift for Readers
INTRODUCTION
NARRATIVE TOOLS
 Plot Points
 Cliffhanger
 Chekhov's Gun
 Ellipsis
 In medias res
 Suspense and Surprise
 Rashomon Effect
 Occam's Razor
 Unreliable Narrator
 The Bookending Technique
 Chinese Boxes
PLOT TROPES
 MacGuffin
 Phlebotinum
 Fish Out of Water
 Rabbit hole
 Chandler's Law
 Foreshadowing
 Breaking the Fourth Wall
 Deus ex machina
 Diabolus ex machina
 Ticking clock
 Red herring
 Gordian Knot
 Red Wedding
 Jump the shark
EPILOGUE
Index of Movies and Series

Bibliography and Resources
Lastly
Acknowledgments

Gift for Readers

You can **download the 25 Narrative Resource Cards** to always have them on hand and apply them to enrich your storytelling. Print the PDF in color on thick paper and cut the cards along the dividing lines.

You can download the free resources from this book at:

https://cursosdeguion.com/recursos-narrativos-ingles-descargas/

INTRODUCTION

What do you remember from the first time you watched *Pulp Fiction*? The music, the performances, the violence, the dialogue? I remember the feeling of never knowing where the story was going. I enjoyed the character introductions and the plot twists that made it impossible to predict what would happen next. Furthermore, I saw it in the theater with some friends when I was just starting out in screenwriting, and even though I hadn't written anything yet, I sensed that the script's construction was more intricate than it seemed at first glance.

Produced on a relatively low budget and distributed by Miramax, a company known for independent films, *Pulp Fiction* proved that movies outside the major studios could achieve massive commercial and critical success. This helped usher in a new wave of independent cinema in the 1990s.

The film blends violence with a dark sense of humor, creating a unique tone rarely seen in mainstream cinema. This drew both praise and controversy, but it undoubtedly helped define Tarantino's distinctive style. His direction also stood out for its unique visual style, which included long takes and creative use of camera angles. The dialogues are witty, filled with cultural references and colloquialisms. As for the soundtrack, it's an eclectic mix of various genres, from surf rock to soul. Tarantino used music not just to accompany the action but as an integral part of the narrative, influencing future filmmakers in their use of non-original music in their films.

And when it comes to screenwriting, *Pulp Fiction* is renowned for its non-linear narrative structure. The film weaves together several stories

in a way that breaks with traditional temporal sequences. This technique wasn't new, but Tarantino used it in a way that captured the attention of both general audiences and critics, rekindling interest in this storytelling approach. Additionally, it's worth noting the wide range of narrative tools he employed, many of which will be analyzed in this book, and which helped intricately weave together the Oscar-winning script.

I will list some of these tools below so you can see what I'm talking about. The film uses the technique of "framed narrative" in the story of the gold watch told to Butch, adding a layer of depth to the story. It employs in medias res, starting scenes in the middle of the action, such as the opening sequence of the diner robbery, which keeps the audience hooked from the very beginning. The scene ends on a cliffhanger that is only resolved at the film's conclusion.

Pulp Fiction's use of the *MacGuffin* is also well-known: the briefcase with its mysterious glowing contents serves as a driving force for the plot, keeping the audience's attention without being essential to the story's development. This element sparks curiosity and keeps the characters in motion, though its true nature remains a mystery. The film also employs the *bookend* technique: the opening scene establishes the theme and tone that will unfold throughout the film, a technique that provides cohesion and structure to the overall narrative, and is brought to a close in the final scene.

When Butch encounters Vincent in the bathroom, he has several options to resolve the situation: try to talk him down, tie him up, run away... but he decides to cut the *Gordian knot* with the simplest solution: shooting him point-blank. Problem solved, no loose ends. Vincent's death is a shocking and unexpected event in the film, similar in some ways to the *Red Wedding* from *Game of Thrones*. It subverts the audience's expectations, as Vincent is a major character whom one would expect to survive throughout the movie.

In the art of screenwriting, we can distinguish between narrative techniques and plot tropes. Narrative techniques are the methods and strategies that writers use to tell a story. They include elements such as the use of ellipses, flashbacks, or unreliable narrators, and are essential for structuring the story and giving it rhythm and depth.

On the other hand, plot tropes are those recurring motifs or themes that appear in various stories. They are like recognizable patterns that help shape the plot, but unlike narrative techniques, they don't dictate how the story is told; rather, they define which common elements can be found in it. Examples of plot tropes include the *MacGuffin*, which is an object that drives the plot but is not significant in itself, or the *cliffhanger*, which keeps the audience in suspense between episodes or parts of the work.

Both narrative techniques and plot tropes are crucial tools in a screenwriter's toolbox, each bringing its own unique value to the creation of a captivating and well-structured narrative. In this book, we delve deeply into each of these tools so that screenwriters have more resources to build their stories.

NARRATIVE TOOLS

Plot Points

> *Every five or ten pages, I want a big fist to come out of the script and punch the reader in the gut.*
>
> — Alan Durand

The first time I heard the term *plot points* was while reading *Syd Field's Screenplay*, a classic manual for screenwriters originally published in 1979. There, he defined the plot point as "an incident, episode, or event that 'hooks' into the action, shifting it in a new direction, with 'direction' meaning a 'line of development.' A plot point can take many forms: a shot, a few words, a scene, a sequence, or an action—anything that advances the story".

For Syd Field, a feature-length screenplay typically contains between 15 and 20 plot points, depending on the story and its runtime. These plot points ensure the story maintains a solid and cohesive structure and drive the plot toward resolution. Field suggests there may be two in Act I, ten in Act II, and one in Act III. However, two plot points are crucial and must be clear from the outset—specifically, the ones at the end of the first and second acts, commonly known as turning points.

What is the purpose of a plot point?

1. Anchoring the Story

One of Syd Field's maxims is that "When you're in the paradigm, you can't see the paradigm." And it's true that if we write a script without a clear structure, we're likely to lose our way amid actions and scenes. Plot points serve as buoys, guiding you through the narrative. Without these buoys, we risk swimming aimlessly until we're exhausted. Plot points anchor the story with key events that hook into the action, steering it in a new direction. For Field, the most important buoys to identify before writing a script are four: the beginning, the end, the plot point at the end of Act I, and the plot point at the end of Act II. With these in place, you can start building the storyline.

2. It moves the story forward

A plot point's primary purpose is to move the story forward. The plot progresses little by little, and each new plot point introduces an incident or event that hooks into the action and steers it in another direction. This keeps the story engaging, as the audience can never fully relax. The moment the audience feels the story has stabilized, another plot point shifts it in a new direction, raising new questions and expectations for the characters. When writing a script, plot points serve as signposts, driving the story forward and holding it together.

The important plot points in a story

While Syd Field suggests that a script can contain up to 20 plot points, not all of them carry the same weight. This chapter explores the key plot points that should appear in every film. While some of these come from Field's analysis, others are classic plot points identified by critics and analysts such as Joseph Campbell, Robert McKee, Blake Snyder, or Linda Seger.

1. Inciting Incident, Call to Adventure...

The inciting incident, as Linda Seger calls it; the catalyst, according to Blake Snyder; the inciting event, as McKee describes it; or the call to adventure, as Joseph Campbell refers to it in *The Hero with a Thousand Faces*, is the event that sets the story's action in motion. Something happens: an explosion, a murder, a letter arrives, or you see a holographic message from a rebel princess asking for help. Perhaps you are given a ring you must destroy... and from that moment, the story takes shape. Now, the backbone of the story is revealed, leading us toward the climax and resolution of the plot. If the backbone represents the structure, the plot points are the vertebrae that support it.

The inciting incident can be a specific action, such as a murder, a breakup, or a kidnapping. It could also be something more precise: a monstrous spirit appearing in the basements of the New York Public Library, as in *Ghostbusters*, or a young woman being devoured by a shark while swimming at night on a peaceful beach, as in *Jaws*. At other times, the inciting incident is conveyed through dialogue—like in many TV movies, where a character learns they have cancer, or their boss calls to inform them they've been fired or promoted.

Some genres have a fixed inciting incident as part of their essence. As the screenwriters of the musical romantic comedy *Explota Explota*, we knew that the inciting incident was the protagonist meeting their love

interest. The meet-cute between the couple is an essential scene, just like the final reconciliation in the happy ending.

2. Turning Points

Syd Field places vital importance on the plot points at the end of the first and second acts in a script's structure. These points serve as guides, goals, objectives, or destinations for each act, forming links in the chain of dramatic action that hold everything together. I prefer to call them turning points because I first encountered them under that name in Linda Seger's *Making a Good Script Great*, where they were translated this way.

Typically, the first turning point appears about thirty minutes into the film, and the second one around twenty to thirty minutes before the end. As mentioned earlier, all plot points share general functions, such as advancing the story and shifting it in a new direction. However, turning points also serve specific functions: they mark the transition into the next act and raise the central question the protagonist must resolve to achieve their goal, creating uncertainty about their success.

The second turning point goes a step further: it accelerates the action. It injects a sense of urgency into the narrative, making the third act more intense than the previous ones and driving the story toward its conclusion. This acceleration often occurs through a countdown or time limit. In some cases, the second turning point unfolds in two parts: a dark moment, where the protagonist reaches their lowest point, followed by a new stimulus that signals their resurgence and leads into the final battle at the climax.

In short films, the structure differs. With a much shorter runtime, they typically follow a two-act structure: setup and resolution. The second act, which develops the story, is omitted due to time constraints. With fewer

acts, there is usually only one turning point dividing the narrative in two, often referred to as the "point of no return."

3. Midpoint

A few years after the publication of *Screenplay*, Syd Field released a second book, *The Screenwriter's Workbook*, in which he revised his paradigm and introduced new plot points into the story structure. Field noticed that the second act often felt endless, stretching from page 30 to page 90 in a 120-page script. After analyzing it, he discovered, in his own words, "Something always happens on page 60. It could be a plot point, a sequence, a scene, a line of dialogue, a decision, some kind of incident, or an event that bridges the two halves of the second act."

Field wasn't the only one to observe this pattern. Blake Snyder recalls that during his early years as a screenwriter, he frequently took long car trips and invented a training method to sharpen his storytelling skills. He would record movies on audio cassettes and listen to the dialogue while driving. He realized that every time he flipped the tape over, a plot point would occur at that transition point. This insight led him to recognize the importance of the midpoint.

For Snyder, the midpoint represents a shift in perception. Things may seem to be going well for the protagonist, but it will only be an illusion, a false or temporary victory. Conversely, the protagonist might feel like everything is going wrong, and they're lost without a clear path forward. In romantic films, the midpoint is often a moment where everything appears perfect—only for cracks to surface shortly after. In a serial killer movie, it could be the ideal moment for a new murder to raise the stakes. The midpoint serves as a crucial moment when the protagonist must reassess their chances of success and confront new challenges.

4. The Pinch Points of the Second Act

In his research on the plot points of the second act, Syd Field developed the concept of pinch points. These are scenes or sequences that "hold" the storyline together, keeping the plot on track during the second act. The first pinch point appears around page 45, in the first half of the second act, and the second pinch point around page 75. According to Field, a pinch point can take the form of a scene, a sequence, or a plot point.

In *Star Wars: Episode VI – Return of the Jedi*, the first act focuses on Han Solo's rescue from Jabba the Hutt. The first turning point occurs when the characters finally leave Tatooine. Upon returning home, Luke Skywalker visits the venerable Jedi master, Yoda. In an emotional and moving scene, Yoda tells Luke that before he can become a true Jedi Knight, he must confront the dark side of the Force—his father, Darth Vader. After this revelation, Yoda dies. This event serves as the first pinch point, appearing around page 45, and ensures that the story stays on course.

The midpoint occurs when the mission to destroy the new Death Star is set into motion. The second pinch point happens when Luke surrenders himself to confront his father. The second turning point follows shortly after, marking the start of the final duel, which alternates with scenes of Han Solo and Leia infiltrating the corridor to deactivate the shield.

There is usually a narrative connection between the first and second pinch points—some type of thematic or plot link. In *Return of the Jedi*, the first pinch point is Yoda's revelation that Luke must face his father, and the second occurs when Luke surrenders to do so. These events are interwoven to ensure the story stays on track. According to Syd Field, this is why the first and second pinch points are often the last elements decided before writing begins.

5. Climax

The climax typically takes place in the final five pages of the script, followed by a brief resolution that ties up any loose ends. The climax serves as the grand finale: it's the moment when the main conflict is resolved, the central question raised by the inciting incident is answered, and the protagonist either succeeds or fails in achieving their goal. At this point, the tension is released, and once the climax concludes, the script should wrap up as quickly and efficiently as possible.

6. Commercial Cliffhanger

Television series often structure their acts around commercial breaks. Before each break, a cliffhanger occurs, creating suspense and building tension until the commercials end. These cliffhangers function as plot points and work similarly to turning points, dividing the narrative into distinct blocks or acts. Each cliffhanger consists of two parts:

1. **Before the commercial break** – A mystery is introduced, generating tension.
2. **After the break** – The mystery is resolved at the beginning of the next segment.

This structure maintains audience engagement across breaks. I will dedicate a full chapter later on to explore this narrative tool in more detail.

The Final Plot Twist

A plot twist in a film is an unexpected change in the direction or outcome of the story that surprises the audience. This twist usually occurs around the middle or end of the narrative and aims to alter the viewer's

perception of the characters or the plot itself. Plot twists are effective for maintaining audience attention and can open new directions in the storyline, revealing that appearances were deceptive or that the situation was different from what it initially seemed. A well-executed twist remains consistent with the story, often built through subtle clues and foreshadowing, while still managing to avoid predictability.

Among the different types of plot twists, the final twist is arguably the most impactful. Films that employ this device redefine everything the audience thought they understood up until that point. This unexpected turn shifts the meaning of the entire story, potentially transforming what the audience knows about the characters and their motivations. However, this kind of twist must be handled with skill to avoid feeling forced or incoherent. A successful final twist is rooted in the plot so that, in hindsight, the audience can recognize hidden clues or details pointing toward the revelation—even if they didn't notice them initially. A well-executed final plot twist not only surprises but also invites reflection and often prompts viewers to rewatch the film with the new perspective it provides.

Final plot twists are a powerful narrative tool that can be integrated into various genres, but they are particularly effective in two specific contexts:

1. **Exploring the blurred line between life and death:**
 In these stories, the twist reveals that a key character—sometimes even the protagonist—has been dead throughout the narrative, existing in a reality that misleads the viewer about what has been presented. This approach plays with the audience's perception of reality and identity. Iconic films like *The Others*, *The Sixth Sense*, and *Jacob's Ladder* follow in the tradition of Henry James' *The Turn of the Screw*, a pioneering work that explores psychological ambiguity and employs unreliable narrators to manipulate the audience's experience.

2. **"Things are not what they seem" narratives:**
 In this type of story, the plot is meticulously crafted to guide the audience toward a particular interpretation of the characters and their motivations, only to reveal, in a final twist, the true intentions and hidden realities. This technique relies on narrative misdirection, often using unreliable narrators or deceptive characters to foster doubt and suspicion. Films like *The Usual Suspects*, *The Game*, *Fight Club*, and *Primal Fear* employ this method to deliver unforgettable endings that invite the audience to rethink past events from a new perspective.

Writing a story with a final plot twist requires careful planning of the plot. If you want to incorporate this tool into your storytelling, I suggest following these steps:

1. **Know the True Ending**
 Before you start writing, it's essential to have a clear understanding of the true ending of your story. This is the final destination for your characters and the main revelation that will change the audience's perception of everything that has happened so far. The true ending must remain consistent with the plot and the characters, even if it is initially concealed from the audience.
2. **Think About the False Ending**
 Once you've determined the true ending, it's time to create a false ending or introduce red herrings that mislead the audience. This false ending must be believable enough to keep the audience emotionally engaged and invested in the narrative, encouraging them to follow the wrong path without suspecting the twist.
3. **Plan the Deception**
 Now, you need to strategically plan how to maintain the deception until the true ending is revealed. This may involve characters who lie, conceal their true motives, or possess hidden agendas. You could also use an unreliable narrator, whose biased or distorted

version of events keeps the audience in the dark. Every scene, line of dialogue, and character development should subtly contribute to the deception, while also leaving breadcrumbs that, in hindsight, point to the real truth.

4. **Design the Plot Twist**
 The plot twist should occur at a narrative climax, delivering a moment of surprise that feels unexpected yet, upon reflection, inevitable. The twist must subvert the audience's expectations, but when it is revealed, all prior elements should fit together like pieces of a puzzle that suddenly make perfect sense.

5. **Adjust the Resolution or Denouement**
 After the plot twist, it's essential to tie up loose ends and ensure the story reaches a satisfying conclusion that reflects the new reality presented by the twist. The resolution should offer the audience a deeper understanding of the characters and plot, leaving them with a sense of closure and, ideally, a desire to revisit the story with their newfound perspective.

Throughout this process, it's helpful to write multiple drafts and continuously evaluate how each element of the story contributes to both the deception and the final revelation. An effective plot twist requires all components of the narrative to work together seamlessly—not only to deceive the audience, but also to deliver a satisfying and coherent experience once the truth is unveiled.

Cliffhanger

Knuckles: "Oh, man, a cliffhanger? I hate those".

Sonic Boom

A cliffhanger (literally "hanging from a cliff" or, more metaphorically, "on the edge of the abyss") is a narrative technique used at the end of a scene—typically at the close of a chapter in a work of fiction (such as a series, comic, book, movie, or video game)—to create suspense and hook the audience, making them eager to discover the outcome in the next installment.

The word "cliffhanger" is highly visual: the author leaves the character figuratively "hanging from the cliff" and stops the narrative at that crucial moment. Later—whether a day, a week, several months (if it's the end of a season), or even 25 years, as in the case of *Twin Peaks*—the story resumes, and we finally learn what happened to the character who was left in suspense.

A cliffhanger can take many forms: it might be a simple image, an action, or even just a single line, depending on the medium and the type of story.

There are two essential elements for a narrative moment to be considered a cliffhanger:

1. **The action is left unfinished.**
 The characters are placed in a complicated or unexpected situation, with the resolution left uncertain. This creates suspense: What will happen next?
2. **It occurs before a narrative pause.**
 This pause can vary in length:
 - A **short pause**, such as a commercial break or the end of a chapter.
 - A **medium pause**, like the end of an episode or a weekly serialized novel.
 - A **long pause**, such as the conclusion of a season or a book that continues in future installments.

Origin of the term Cliffhanger

The idea of leaving the audience in suspense is almost as old as literature itself. Even in *One Thousand and One Nights*, Scheherazade repeatedly used this technique by leaving the king eager to know what would happen next, thus postponing her execution for at least another day.

The term "cliffhanger" first appeared in the Oxford Dictionary in 1937. Its origin, however, traces back to the serialized novel *A Pair of Blue Eyes*, published in 1873. Released in monthly installments in newspapers, the story's author, Thomas Hardy, ended one chapter with the protagonist

literally hanging from a cliff. This narrative device was so effective that it quickly became a trope in serialized fiction, gaining popularity in Victorian novels, French feuilletons, and American pulp literature. Over time, the cliffhanger evolved, transitioning to radio, comics, film serials, and finally the medium that cemented the term in popular culture: television.

The first time I experienced the impact of a cliffhanger was with the iconic shooting of J.R. in *Dallas*. In the scene, someone shoots J.R., the series' villain, in his office, but the shooter's identity remains unknown. I still remember the question that dominated conversations for months until the series returned: "Who shot J.R.?"

Today, some series have made cliffhangers their trademark, including *24, Prison Break, Alias, Battlestar Galactica, Game of Thrones*, and *The Walking Dead*. The season finales of *Lost* are especially legendary. The first season ended with the opening of the hatch, hinting at deeper mysteries on the island. The third season finale subverted the show's established structure—introducing flash-forwards, time travel, and flash-sideways—and ended with the unforgettable line: "We have to go back!", leaving viewers stunned.

In any medium that divides the narrative into installments or chapters, the cliffhanger is a highly effective tool for keeping the audience, reader, or player on edge until the situation is resolved. Interestingly, there's a scientific explanation for this effect, known as the Zeigarnik Effect. This psychological phenomenon suggests that we tend to remember unfinished or interrupted tasks more easily than those we've completed.

The phenomenon is named after psychologist Bluma Zeigarnik, who became interested in it after observing how a waiter could easily recall a long list of pending orders but struggled to remember the dishes he had already served. In 1927, Zeigarnik published a study that investigated this phenomenon. She asked participants to complete 18 to 21 tasks (including puzzles, arithmetic problems, and manual activities), but half of the tasks

were interrupted before they could finish them. The results showed that participants recalled the unfinished tasks more vividly than the completed ones.

What Is the Purpose of a Cliffhanger?

If you're considering using this device in your work, here are four reasons why you should:

1. **It Generates Suspense**
 A cliffhanger creates the classic "What will happen next?" moment. It sparks curiosity, provides a hook, and fosters loyalty. The audience becomes emotionally invested in the plot and cares about the characters. If one of them is in danger or a surprising revelation occurs, viewers will feel compelled to see how the situation resolves.
2. **It Provides Continuity to the Story**
 Cliffhangers connect episodes and give the narrative cohesion. In some cases, a significant amount of time passes between the last episode of one season and the first of the next. A cliffhanger helps bridge that gap by leaving unresolved tension or mystery that will be addressed later.
3. **It Serves as a Teaser for Future Plots and Stories**
 At the end of a season, cliffhangers can tease upcoming plots and generate anticipation. For example, at the end of *Narcos* season 2, after Pablo Escobar's death, the question arises: What will the next season be about? The final episode hints at future conflicts. Similarly, in *Stranger Things* season 1, an officer leaves Eleven's favorite food in the woods, suggesting she might still be alive. However, new storylines introduced through cliffhangers don't always get resolved. For instance, season 4 of *Masters of Sex* sets up new plots that remain unresolved due to the show's cancellation.

4. **It Helps the Audience Remember the Story**
 As we discussed earlier, the Zeigarnik Effect explains that unfinished plots are easier to remember than completed ones. This psychological effect helps viewers retain the story until the next installment, keeping them engaged over time.

How to Use a Cliffhanger

A cliffhanger has two phases: the setup and the resolution. The setup is the moment when tension is created—placing a character in danger or introducing a mystery. After the pause, the resolution reveals how the interrupted sequence concludes. Depending on when the resolution occurs, we can identify different types of cliffhangers:

- **Within the installment** (episode, book, video game):
 The resolution happens within the same installment, providing quick closure.
- **Outside the installment** (episode, book, video game, movie):
 - **In the next episode.**
 - **In the next season.**
 - **Without resolution:**
 Some series are canceled, leaving cliffhangers unresolved. Others intentionally leave open-ended finales, as in *The Sopranos*. Its creator, David Chase, deliberately avoided revealing whether Tony Soprano lives or dies. The series famously ends with a sudden fade to black in the middle of what seems like an ordinary family dinner. This ambiguous ending left viewers to interpret the outcome for themselves. However, on the night it aired, some viewers called HBO's technical support, believing their broadcast had been cut off. But no—*The Sopranos* really ends on a major cliffhanger.

The Cliffhanger Principle and Theorem

Although cliffhangers aren't an exact science, I've created a principle and a theorem to round out the concept:

- **Cliffhanger Principle:**

 "The dramatic intensity of a cliffhanger must be directly proportional to the time that will pass before its resolution."

 If the pause is short, the cliffhanger shouldn't be too dramatic, as it might overwhelm the audience or lessen its impact. The most spectacular cliffhangers should be reserved for season finales or major breaks.

- **Cliffhanger Theorem:**

 "The secret of the cliffhanger lies not in creating it, but in resolving it satisfactorily."

 A cliffhanger must deliver on its promise. It's not enough to generate excitement and then resolve it in a forced, irrelevant, or unsatisfying way. Doing so risks losing the audience's interest instantly.

Cliffhangers in Different Media

In film franchises, cliffhangers are used to link one movie to the next. Memorable examples include the endings of *Star Wars: Episode V – The Empire Strikes Back* and *Kill Bill: Volume 1*.

In video games, cliffhangers often appear when sequels are planned. For example, in trilogies, it's common for the first two games to end with cliffhangers that leave a mystery to be solved in the next installment.

In comics, cliffhangers frequently appear at the end of right-hand (odd) pages to compel readers to turn the page. Although it's unnecessary to end every page with a dramatic cliffhanger (remember the Cliffhanger Principle), there should always be enough intrigue to keep readers engaged until the end.

A Cliffhanger for Screenplay Readers

There's also a lesser-known type of cliffhanger that screenwriters must master: the cliffhanger for script readers. Production companies often have piles of unread scripts, and readers typically decide within the first 10 pages whether they want to continue.

Our goal is to hook the reader from page one and ensure they feel compelled to move on to the second page, then the third, and so on. If we can get past the first 10 pages, we've overcome the hardest part. To achieve this, it's helpful to place small cliffhangers at the end of each page—not necessarily something dramatic, but enough to raise a question or spark curiosity, motivating the reader to keep going.

Chekhov's Gun

If in the first chapter you say that there's a rifle hanging on the wall, in the second or third chapter it absolutely must fire. If it's not going to fire, it shouldn't be hanging there.

— Anton Chekhov

The narrative device known as Chekhov's Gun is a dramatic principle that asserts that every element in a story must be necessary and irreplaceable; if not, it should be removed. The term Chekhov's Gun comes from the renowned Russian author Anton Chekhov, who famously said that if a gun is hanging on the wall in the first act of a play, it must be used at some point later in the story.

This principle suggests that **every detail in a narrative should have a purpose and be tied to the main plot**. If an object, character, or event is introduced, it must eventually play an important role in the story. Conversely, if an element does not contribute to the plot, it should be eliminated to avoid confusing or misleading the audience.

While Chekhov's Gun can work in your favor by building expectations and maintaining narrative focus, it can also backfire if the audience is led to expect something significant that never happens, resulting in disappointment or a sense of broken expectations.

Origin of Chekhov's Gun

The term Chekhov's Gun originates from advice given by the renowned Russian playwright and writer Anton Chekhov. In various letters and comments, he expressed an idea that has been summarized in the now-famous axiom: "If in the first act a rifle is shown hanging on the wall, then in the second or third act, it must be fired. If it's not going to be fired, it shouldn't be there." This statement encapsulates the principle that every element in a narrative must be necessary and serve a purpose.

There are other versions of this idea. One claims that Chekhov said: "If at the beginning of a story it is mentioned that there is a nail in the wall, that nail must be used at the end to hang the protagonist." Another version suggests the nail could be used "to hang a picture."

The expression "Chekhov's Gun" was not coined by Chekhov himself but emerged later as a way to summarize his advice on writing. Chekhov emphasized the importance of avoiding superfluous elements in a narrative. Any element introduced must serve a clear function—whether to advance the plot, develop a character, or contribute meaningfully to the story in some way.

Examples of Chekhov's Gun in Film

The Shawshank Redemption: Throughout the film, Andy Dufresne works on a rock-carving project, which appears to be an innocent hobby. However, by the end, it's revealed that he has been using the rock hammer to dig a tunnel and escape from prison.

Star Wars: Episode IV – A New Hope: Early in the film, Luke Skywalker receives a lightsaber, which at first seems like a sentimental gift.

Later, the lightsaber becomes essential in Luke's journey, particularly during his final confrontation with the Empire.

Jurassic Park: At the beginning of the film, we learn that the T-Rex is attracted to movement. This seemingly trivial detail becomes crucial later when the characters try to escape the T-Rex by remaining still to avoid detection.

Back to the Future: In the opening scene, Doc shows Marty a video demonstrating the flux capacitor with the DeLorean. The flux capacitor later becomes a key plot device that enables the time travel central to the story.

Harry Potter Series: Throughout the Harry Potter books and films, several examples of Chekhov's Gun can be found. For instance, in *Harry Potter and the Philosopher's Stone*, Harry receives an invisibility cloak as a Christmas gift. What initially seems like a simple present becomes an essential tool in various key moments throughout the series.

The Anti-Chekhov

In literature and film, there are instances where the principle of Chekhov's Gun is intentionally broken to achieve specific effects, such as surprising the viewer, creating an atmosphere of uncertainty, or subverting audience expectations. These cases are known as Anti-Chekhov or False Chekhov.

An example of this can be found in the film *No Country for Old Men*. In their adaptation of Cormac McCarthy's novel, the Coen brothers present a scenario that seems to prepare the viewer for a classic showdown between the protagonist, Llewelyn Moss, and his pursuer, Anton Chigurh.

However, this anticipated confrontation never happens on screen. The viewer expects a climactic encounter—following the narrative

convention suggested by Chekhov's Gun—but this expectation is subverted when Moss is killed off-screen. The audience only learns of his death through a conversation between secondary characters. This narrative twist defies the audience's expectations, delivering a sense of raw realism and fatalism that aligns with the film's overarching themes.

Breaking the convention of Chekhov's Gun demonstrates how screenwriters can manipulate audience expectations to produce unexpected dramatic effects or emphasize certain themes or narrative styles. In *No Country for Old Men*, the rejection of a conventional showdown highlights the unpredictable and senseless nature of violence and fate—central themes in both McCarthy's novel and the Coen brothers' adaptation.

How to Use Chekhov's Gun to Give Coherence to the Plot

Here are **eight keys** to applying Chekhov's Gun effectively in your scripts or stories:

1. **Eliminate Unnecessary Elements**

This principle focuses on narrative economy: anything that doesn't contribute to the plot or character development should be removed. This keeps the story focused and prevents distracting the audience with irrelevant details. By removing the superfluous, the essential elements become stronger, ensuring that every scene, line of dialogue, and description serves a clear purpose. F. Scott Fitzgerald is known for his concise storytelling, as seen in *The Great Gatsby*, where every detail advances the plot or supports central symbolism. Similarly, Ernest Hemingway's *The Old Man and the Sea* exemplifies this economy, with every element contributing to the core narrative.

2. **Strengthen the Plot**

Every element introduced—whether a character, object, or line of dialogue—should play a role in advancing the plot. For example, a secondary character introduced early on must influence the story later, or an object highlighted in the beginning must become crucial at a turning point. This creates cohesion and ensures the narrative has a sense of purpose. In *The Da Vinci Code* by Dan Brown, every clue, character, and location introduced contributes to solving the central mystery.

3. Develop the Characters

Story elements should also serve to reveal and develop characters. This can happen through their interactions, reactions to events, or how they relate to specific objects. Even minor characters can reveal important aspects of the protagonist or become pivotal to the plot. In *Fight Club*—both the novel by Chuck Palahniuk and the film by David Fincher—objects and events in the narrator's life provide insight into his fractured psyche.

4. Create and Meet Expectations

When an element is introduced, it creates expectations in the audience. A successful story often depends on how well these expectations are fulfilled or subverted. If a mystery is raised, the audience expects a satisfying resolution. Meeting or skillfully subverting these expectations can greatly affect how the story is perceived. In *The Prestige* by Christopher Nolan, several mysteries are introduced early on, all of which receive surprising resolutions by the end.

5. Use Foreshadowing

Foreshadowing involves planting subtle hints or clues about future events in the plot. These hints can be direct or indirect, but they must be relevant and consistent with the story's development. Effective foreshadowing builds tension and anticipation, making the resolution

more satisfying. In *Jane Eyre* by Charlotte Brontë, Jane's dreams and the mysterious fire are early hints that foreshadow key future events.

6. Avoid Distractions

Keeping the narrative focused by avoiding irrelevant elements helps maintain the audience's attention on the main plot and character arcs. This is particularly important in film, where screen time is limited, and every scene needs to contribute meaningfully. Christopher Nolan's *Dunkirk* maintains a strict focus on the evacuation of soldiers, avoiding unnecessary romantic or political subplots.

7. Provide Closure and Resolution

A satisfying story resolves the important elements introduced throughout the narrative. This doesn't mean every story needs a happy or definitive ending, but the questions raised and conflicts established should be addressed in some way, providing a sense of closure. For example, *The Godfather Part II* resolves all of Michael Corleone's family plotlines by the end, offering a complex but complete narrative arc.

8. Three Steps to Applying Chekhov's Gun

To apply Chekhov's Gun effectively, follow these three steps:

A. Choose the Right "Gun" for Your Story

Select a significant object relevant to the plot's development. Consider how the gun can symbolize conflict, trigger important events, or reveal key details about the characters.

B. Introduce the "Gun" Subtly and Naturally

Once chosen, the gun should be introduced organically into the narrative. Avoid making it the main focus of a scene; instead, integrate it through dialogue, actions, or visual descriptions. The goal is for the

audience not to realize the gun's importance until its true purpose is revealed later in the story.

C. Use the "Gun" to Resolve the Conflict

Ensure that the gun becomes a key element in resolving the central conflict. Its presence should heighten dramatic tension and create impactful moments. Avoid giving obvious hints about the gun's role in the resolution, as this will preserve the element of surprise and keep the audience engaged until the very end.

Ellipsis

We observe a group of primates in a confrontation, and one of them shows a sign of intelligence by hitting another with a bone, then throws it into the air. A vertical pan follows the bone's trajectory until it ends in outer space, precisely on a satellite. In that transition, director Stanley Kubrick makes a leap of 4 million years in nearly 13 seconds of sequence.

Daniel Hidalgo

As explained in the first class of any film school, cinema is a sequential art divided into shots, scenes, and sequences. These components are arranged according to a certain logic during editing, creating a sense of time. Like playwrights and novelists, filmmakers select significant elements of their story and organize them in the film. Although it may seem obvious, it's important to emphasize that filmmakers don't need to show everything to tell a story. They decide what to show and what to omit, leaving it to the viewer to reconstruct the story in their mind. In this sense, **cinema can be described as the art of ellipsis**. To master this tool, it's essential to distinguish between real time (the time that passes in reality) and cinematic time (which is constructed in the film and can be extended, shortened, or rearranged).

In 1896, an operator for the Lumière brothers was filming the Tsar's visit to Paris. Due to limited film stock, he decided to record the

event in parts. When they later viewed the footage in sequence, they realized that, even though parts of the event were missing, the narrative still made sense. We could say that this is how ellipsis was born—in a time when cinematic language was still being developed. Early silent films used ellipsis through intertitles and later through fade-outs to black.

In literature, ellipsis is a grammatical device that involves omitting one or more words from a sentence while preserving its meaning. In theater, ellipsis was generally limited to the transition between acts, implying the passage of time. In cinema, an ellipsis is a jump in time or space. Although intermediate steps are omitted, the viewer can still follow the sequence without losing continuity.

Today's viewers are highly familiar with audiovisual language and easily understand shifts in time and space. Certain mediums—such as video art, music videos, and advertising—frequently employ temporal shifts. In addition to ellipsis, these formats often manipulate the speed of shots, either by accelerating the images (as seen in comedic films) or by using slow motion for dramatic effect.

Types of Ellipsis in Films

To fully understand ellipsis in all its complexity, it's helpful to classify it based on purpose, distinguishing between functional ellipses, narrative ellipses, and those with an expressive character.

1. Functional Ellipsis

Functional ellipses are used to remove unnecessary segments of time or action, often for practical reasons, such as maintaining the film's

runtime. For example, if a character sets up a coffee machine, the director may choose not to show the full two minutes it takes to brew the coffee, condensing the moment to a few seconds. Similarly, a shaving scene may skip over the tedious, real-time process, showing only key moments.

This type of ellipsis is primarily the director's decision and doesn't concern the screenwriter directly. The action will still appear in the script, but the director will determine how much time to include or omit. The viewer intuitively fills in the gaps left by these functional ellipses.

A well-known example of functional ellipsis is the jump cut, a short ellipsis within the same scene. A jump cut creates an abrupt transition, often on the same image, resulting in a noticeable "jump" in time. This technique can enhance dynamism or add aesthetic flair. Jean-Luc Godard popularized the jump cut in the 1960s, challenging cinematic conventions with his unique style. Today, YouTubers frequently use this type of ellipsis for practical purposes: instead of filming multiple takes, they record everything in one go and later cut out pauses or unwanted parts to streamline their videos.

2. Narrative Ellipsis

Narrative ellipses are a powerful tool for screenwriters, allowing them to shape the flow of the plot. They serve two primary purposes, depending on the desired effect:

A. Controlling the Pace

One of the screenwriter's key tasks is to manage the pace of the story. This involves both the internal rhythm of individual scenes and the overall narrative pace. In the third act, for example, as the story builds toward its climax, scenes are often shortened to increase tension. A faster

pace can be achieved through shorter scenes and frequent transitions, intensifying the dramatic effect.

Ellipses are particularly useful for removing "dead time" and showing only the moments relevant to the plot. For example, a one-hour meeting can be condensed into five minutes, or thirty years of a castaway's life on a desert island can be summarized in an hour-long film.

If you want to shorten a scene without creating a new one, ellipsis can be introduced using transitions. Traditionally, a change in time or space signals a new scene, but transitions allow you to cut irrelevant moments within a scene while maintaining continuity.

The process is straightforward: after a block of dialogue or description where the ellipsis is needed, insert the **transition** in screenplay format. Choose the appropriate type of transition, such as:

- **CUT TO**
- **DISSOLVE TO**
- **FADE TO**

After the transition, continue with the new description, reflecting the time that has passed.

An example of this technique can be found in *Caníbal*, written by Alejandro Hernández and Manuel Martín Cuenca, where transitions are used to introduce subtle ellipses that enhance the pacing and storytelling.

```
INT. DAY. CABIN. SIERRA NEVADA

Carlos has placed the woman's body on a large
marble table. He moves with the confidence of
someone used to routine. He undresses her. We
see fragments of their bodies. Still, we never
get a clear image of Carlos.
```

 CUT TO

For a moment, Carlos observes the body of his
victim. He approaches her. Smells her. His hand
caresses the skin. Sensually.

 CUT TO

A fireplace with a strong fire burning.
Carlos's hands throw the woman's clothes into
the fire. Piece by piece. They start to burn.
We linger for a few seconds, watching the
flames.

 CUT TO

We see a fragment of the body on the marble
table. Silence. Carlos's hand caresses the
body, sensually. Suddenly, the sound of an
automatic knife cutting through flesh and bones
is heard. Carlos, off-screen, begins to
dismember the body. Blood spreads across the
marble. As it reaches the edge, it starts to
drip. We watch the liquid fall.

If you want to learn more about **standard screenplay format**, I explore its characteristics in my book *El formato de guion. Guía para escribir como un guionista profesional*, available on Amazon.

The most common way to control pacing with ellipsis involves ending a scene at one point and starting the next scene later, possibly in a different location. The viewer intuitively understands that a space-time jump has occurred and integrates this shift into their understanding of the story. These jumps can be categorized into two types, depending on how time is indicated:

An **indeterminate ellipsis** occurs when the duration of the time skipped is not explicitly clarified. It could be hours, days, or even years later, but the exact amount of time remains unclear. However, the audience still understands that a time jump has taken place.

A good example of indeterminate ellipsis can be seen in Boyhood. The film was shot over 12 years, with one week of shooting each year, portraying the growth of the protagonist and his family. No on-screen marker indicates the passage of time between these years. Sometimes the ellipsis becomes apparent through visual cues, such as the boy's haircut or height, but other times, it takes several moments into the new scene to realize what has changed. Significant events also happen during these ellipses—the parents separate, for instance, but this is not shown directly. Instead, the audience gradually notices that the father no longer lives with his children.

A **determinate ellipsis** explicitly indicates the duration of the time skipped. This can be achieved through various methods, such as:

- **Sound elements**: character voices, voiceover narration, or soundtrack cues.
- **Graphical elements**: on-screen text such as **"One month later"** or **"Ten years later."**

An example of a determinate ellipsis appears in *Cast Away*, where it is clearly stated that the narrative jumps four years forward on the island, marking a significant shift in the story's progression.

B. Controlling Suspense

In addition to managing pacing, screenwriters can use ellipsis to control the flow of information and generate suspense by omitting key details. For example, in a detective film, if we see a character about to be shot, but the scene cuts just before the shooter is revealed, the ellipsis is used to withhold information from the audience.

Sometimes, the omission of information affects both the audience and the characters. For instance, if the shooter fires from behind and no one sees their identity—not the character nor the viewer—both are left in the dark.

In many cases, the missing information isn't lost forever but reappears later through a flashback. When the moment arrives, the suspense will be resolved, and the identity of the killer—initially hidden by the ellipsis—will be revealed.

3. Expressive Ellipsis

Screenwriters can also use ellipsis with a purely expressive or metaphorical intention. In these cases, the ellipsis becomes a reflection on the passage of time, adding depth to the narrative.

A classic example is found in *2001: A Space Odyssey*, when a monkey throws a bone into the air, and it transforms into a satellite, symbolizing the evolution of human technology. This ellipsis serves two purposes:

1. **Omitting the entire human history** in between, as Kubrick is interested in exploring **the past and the future**, rather than the present.
2. **Connecting both moments** to represent human evolution—first, the bone as a tool, followed by the spaceship as the final step in the chain of learning.

In this case, the continuity between the two scenes is achieved through the motion of the object: the bone spinning through the air and the spaceship in orbit.

In medias res

Latin locution (pronounced [in-médias-rrés])
meaning "in the midst of things, in the middle of the action."

In medias res is a literary and narrative technique that involves beginning a story in the middle or at a crucial point, rather than starting with a gradual introduction. This approach is used to immediately capture the viewer's or reader's attention, throwing them directly into the action or a significant moment in the plot.

By using in medias res, the writer or screenwriter skips preliminary events or expository development that would typically establish the setting, characters, and conflict. This creates a sense of mystery or urgency, as the audience must piece together the context as the story unfolds. Flashbacks, dialogue, or narration later reveal the background and events leading to the current situation. Today's readers and viewers trust that, as the narrative progresses and the characters develop, the story will gradually fill in these gaps.

This technique is common in contemporary storytelling. As Balló and Pérez note in *El mundo, un escenario*:

"Nowadays, we have the feeling, thanks to the internet and social media, that everything can happen at any moment. In a large percentage of today's audiovisual products, the first scene shows characters already talking as if the story had begun long before. The viewer feels that life is flowing, that everything existed before we connected with the scene, and that the narrative is in motion, demanding our attention without waiting for us."

Origin of the Term

The term *in medias res* comes from Latin and means "in the middle of things." It originates in classical poetics, particularly from the Roman poet Horace. In his *Ars Poetica*, written around 19 B.C., Horace advised poets to begin their narratives in the midst of the action rather than with an expository introduction.

Long before Horace, Greek epic poets like Homer used this technique. For instance, in *The Iliad*, Homer begins the story in the tenth year of the Trojan War, skipping the origins of the conflict. This allows the narrative to focus on key events and themes from the start, maintaining the audience's interest.

Related Terms: Ab Ovo and In Extrema Res

Alongside *in medias res*, two other Latin terms describe different ways to begin a story:

- **Ab ovo** ("from the egg"): This refers to starting the narrative at its **chronological beginning** and following a linear sequence of events from start to finish.
- **In extrema res** ("at the extreme of the thing"): This technique begins the story **at the end**, showing the characters in the final

stages of their journey or conflict. The narrative then **looks back**, revisiting earlier events and employing temporal shifts.

Why In Medias Res is Effective

In medias res has become a fundamental narrative technique in literature, theater, and film because it immediately engages the audience, creating intrigue while allowing for deeper exploration of characters and events through flashbacks and other narrative devices.

This technique is versatile: it can be used to open an entire story or to begin individual scenes within a broader narrative. When used in specific scenes, the goal is to maintain narrative momentum and avoid slowing the story down with unnecessary details.

For example, a scene might begin in the middle of an argument, where the characters' dialogue and actions reveal key points without requiring extensive setup. This approach helps accelerate the pace, avoid monotony, and keep the audience engaged. Additionally, it highlights important moments in character development or plot progression.

Characteristics of Using In Medias Res

This technique can have a significant impact on the overall structure of a story, altering both the presentation of information and the audience's experience. Below are some of the key ways in which *in medias res* influences storytelling:

1. **Immediate Hook**

By starting in the middle of the action or at a significant moment, in medias res instantly captures the audience's attention. This is especially effective in mediums like film or television, where engaging the audience quickly is essential. For example, *Saving Private Ryan* begins with the intense D-Day sequence, immersing viewers in the chaos of battle without

prior exposition. As the story unfolds, we gradually learn about the characters and their goals—keeping us "hooked" from the start.

2. Non-Linear Narrative

Stories that use in medias res often employ a non-linear structure, revealing events out of chronological order through flashbacks, memories, or dialogue. This adds complexity and depth to the plot. In *Lost*, the narrative begins moments after a plane crash. Amid the chaos, we meet the survivors and slowly uncover the mysteries of the island through flashbacks that explore the characters' lives before the crash.

3. Mystery and Curiosity

Omitting the early events of the story creates a sense of mystery, motivating the audience to keep watching or reading to discover how the current situation came to be. In *One Hundred Years of Solitude*, Gabriel García Márquez opens with the famous line: *"Many years later, as he faced the firing squad, Colonel Aureliano Buendía was to remember that distant afternoon when his father took him to discover ice."* This sentence raises immediate questions: How did Buendía end up facing a firing squad? The only way to find out is to continue reading.

4. Character Development Through Action

By beginning in the midst of the action, characters are defined by their decisions and behavior in critical moments, rather than by exposition. For instance, in *Vertigo* by Alfred Hitchcock, the film opens with a police chase across the rooftops of San Francisco, culminating with the protagonist hanging from a ledge, helplessly witnessing his colleague's death. This sequence introduces the protagonist's defining trait: his fear of heights, which becomes central to the story.

5. Manipulation of Narrative Time and Space

In medias res allows writers and filmmakers to play with time and space, shifting between periods and locations to enrich the narrative. In *Pulp Fiction* by Quentin Tarantino, the story opens with Tim Roth saying, *"Forget it, it's too risky,"* in the middle of a conversation about a robbery. The scene ends just as the robbery begins, leaving us in suspense. The rest of the film follows multiple non-chronological stories, and only by the end do we understand how the robbery fits into the larger narrative.

6. Retrospective Exposition

Background information is revealed retrospectively, making exposition more engaging and dynamic. In *Lord of the Flies* by William Golding, the story begins with children struggling to survive on a deserted island. There's no detailed explanation of how they arrived; we jump straight into the conflict. The focus shifts to the characters' behavior and group dynamics, with only minimal background details revealed later.

7. Unique Resolutions

A story that begins in medias res may resolve differently from one with a linear structure. The narrative might return to the starting point to close the cycle or end at a different moment, depending on how the events unfold. In *Memento* by Christopher Nolan, the story begins with a Polaroid photograph of a dead man, raising immediate questions. The narrative then moves backward, with the final scenes recontextualizing everything we've seen and providing resolution.

8. Reinterpretation of Events

As the narrative progresses, the audience gains new insights into past events, leading to a deeper understanding of characters' motivations and actions. In *Citizen Kane*, the story opens with the death of the protagonist, whose final word is "Rosebud." The film gradually reveals the meaning of this word, inviting the viewer to reinterpret the character's life and understand his motivations by the end.

9. Subverting Audience Expectations

In medias res subverts traditional storytelling expectations, keeping the audience engaged by disrupting the usual narrative flow. Adventure films like *James Bond* or *Indiana Jones* often begin with immediate action sequences, immersing the audience in thrilling moments without setup. These spectacular openings establish the genre's tone and prepare the viewer for the exciting adventures that follow.

Suspense and Surprise

> *Suspense is a threat of violence and danger, which sometimes becomes a reality.*
>
> Patricia Highsmith

Suspense is a narrative device used across literature, film, series, comics, and video games with the primary goal of keeping the reader or viewer anticipating what might happen to the characters, thereby maintaining their engagement in the story. To generate this anticipation, the narrative places the characters in a state of tension, anxiety, and uncertainty, creating an urgent need in the audience to find out what happens next.

Suspense isn't limited to horror, life-threatening scenarios, or dangerous situations. It can arise in more subtle contexts. For example, there is suspense when we see the protagonist of a movie walking down a deserted street at night, knowing that a group of robbers is waiting to ambush him. But suspense can also occur in seemingly ordinary situations. Imagine a girl who wants to confess her feelings to a classmate she likes. She gathers the courage to approach him but is too scared to express herself. As she hesitates, the boy asks her a question, and though she tries to answer,

she freezes. The audience feels the tension, wondering if she will finally confess—and if so, how he will respond.

Viewers feel suspense because they empathize with the characters, and in many ways, suspense mirrors our own lives. We've all faced situations where uncertain or painful outcomes were possible, leaving us anxiously waiting to see what would happen. Just as we experience suspense in real life, we feel it in stories—our minds filled with uncertainty about what lies ahead, often imagining unpleasant outcomes.

Suspense arises from uncertainty about the future, which is why it is sustained by delaying resolutions, generating stress and tension. A suspenseful narrative slows down events, making us think that something is about to happen—only to delay the moment further, heightening the tension until the resolution finally comes.

A cliffhanger is a powerful tool to intensify suspense. When a suspenseful scene is interrupted—such as during a commercial break—the audience remains in a state of intrigue, eagerly waiting for the story to resume and the situation to be resolved.

Difference Between Suspense and Surprise

Many people confuse suspense with surprise, as both are narrative devices that manipulate the flow of information between the characters and the audience. However, they operate in different ways. To understand the distinction, there is no better example than the one Alfred Hitchcock shared with François Truffaut in their legendary interviews, later compiled in the book *Le Cinéma selon Alfred Hitchcock*:

> "Now we are having a very innocent conversation. Suppose there's a bomb under this table between us. Nothing happens, and then suddenly—Boom! There's an explosion. The audience is surprised, but until that moment, they have

witnessed a seemingly ordinary scene with no special consequence.

Now, let's consider a suspense situation. The bomb is still under the table, but this time the audience knows it's there—perhaps because they saw the anarchist place it. The audience also knows the bomb is set to explode at one o'clock, and there's a clock visible in the scene. It's now a quarter to one. Suddenly, this seemingly trivial conversation becomes intensely gripping because the audience is actively engaged, eager to warn the characters: *'You shouldn't be talking about such trivial matters—there's a bomb at your feet, and it's about to explode!'* In the first case, we've given the audience fifteen seconds of surprise with the explosion. In the second case, we've provided them with fifteen minutes of suspense as they anxiously await the outcome. The conclusion is that, whenever possible, the audience should be informed."

The Matrix of Suspense and Surprise

I've created a four-quadrant matrix to explore the different ways in which surprise and suspense can be used. The horizontal axis distinguishes between the characters and the audience, while the vertical axis separates surprise from suspense. By crossing these values, we get the following four possibilities:

	Character	Audience
Surprise	Surprise for the Character (SRC)	Surprise for the Audience (SRA)
Suspense	Suspense for the Character (SSC)	Suspense for the Audience (SSA)

1. Surprise for Both the Character and the Audience (SRC + SRA)

In this scenario, both the characters and the audience experience a surprise simultaneously. In Hitchcock's example, this would occur if the bomb suddenly exploded without any prior warning. Both the audience and the characters would be caught off guard, leading to a moment of confusion and shock. However, as Hitchcock points out, this kind of surprise only lasts a few seconds.

2. Surprise for the Character, Suspense for the Audience (SRC + SSA)

In this case, the audience knows more than the characters, creating suspense. In Hitchcock's example, the audience has seen the bomb being planted and watches anxiously, hoping the characters will leave the room before it explodes. This structure is common in spy, crime, and horror films. For example, in *The Silence of the Lambs*, we know that Buffalo Bill is the man who opens the door to Clarice, and we wish we could warn her about the danger she's walking into.

3. Suspense for the Character, Surprise for the Audience (SSC + SRA)

Here, the characters are aware of a threat, but the audience is not. As a result, the audience is surprised when the danger is revealed. For example, a character might have a bomb strapped to their body, but because they are clothed, the audience doesn't know this yet. We see the character sweating and behaving nervously, but we don't understand why until the bomb is revealed, catching us by surprise.

4. Suspense for Both the Character and the Audience (SSC + SSA)

In this scenario, both the characters and the audience are aware of the threat, creating shared suspense. This structure is typical of horror and spy stories. For example, the protagonist enters a mysterious house after being warned that a bomb has been planted inside. Both the character and the audience know that each step could trigger an explosion, and as the character moves cautiously, we share their fear and tension, dreading what might happen next.

The 5 Steps to Create Suspense

Now that we have a clear understanding of what suspense is, let's explore how to create it in our stories through five key steps:

1. The Announcement

To generate suspense, the audience must be informed. They need to know what the protagonist wants, what the antagonist's plans are, and feel that something is about to happen. In Hitchcock's example of the bomb under the table, the audience is first told that anarchists have planted a bomb and that it will explode in a few minutes.

2. The Delay

While the bomb could explode within seconds, the storyteller chooses to delay the explosion by 15 minutes, extending the tension. The characters continue their conversation, unaware of the impending danger. The audience hopes for some interruption—perhaps someone calls, or a character feels the need to leave. But the conversation gets more animated, and the characters stay seated, oblivious to the ticking bomb. Although what they're discussing may seem trivial, the tension is sustained because the audience knows about the bomb.

3. Reduction of Alternatives

To heighten the tension further, the storyteller reduces the possible outcomes, leaving the audience focused on just two possibilities:

- Will the bomb explode or not?
- Will the characters live or die?

This narrowing of options prevents the audience from getting distracted with other possible solutions. For example, one character might receive a phone call urging them to leave—but they ignore the request and remain seated at the table... with the bomb underneath.

4. Exaggeration of the Delay

This step involves delaying the resolution even further by introducing unnecessary actions. For instance, a character might order another coffee, signaling that the conversation will continue for a while. Another character might go to the restroom, only to find it out of order, forcing them to return to the table. This technique stretches time to the maximum, increasing the audience's anxiety as they remain the only ones aware of the bomb (besides the person who planted it).

5. Resolution

Finally, the situation must be resolved. Whether the bomb explodes or not depends on the narrative goals. If the bomb goes off and harms the characters, the audience will have suffered along with them. However, if the characters escape just in time, the tension pays off, and the audience breathes a sigh of relief. Either way, the resolution is crucial to the emotional impact of the scene.

Rashomon Effect

> *Marge: Come on, Homer. Japan will be fun! You liked Rashomon.*
>
> *Homer: That's not how I remember it!*
>
> The Simpsons, "Thirty Minutes Over Tokyo"

Works of fiction are presented to the audience through a singular perspective, carefully chosen by the creator to shape the narrative experience. This point of view is not random; it is a conscious decision that determines how the story will be perceived. The creator acts as a conductor, meticulously controlling every aspect of the story: the amount of information revealed, the moment of its disclosure, and the lens through which it is filtered—whether through a specific character or an omniscient narrator. Typically, stories are told from a single perspective.

The Rashomon Effect is a narrative technique that challenges the norm by telling a single story from multiple points of view, emphasizing the subjectivity of each character's perception. This technique explores how individual perspectives are influenced by various factors—such as limited information, memory, beliefs, gender, age, or even personal desires.

The characters' differing versions of the same event may all seem true, though they are often incompatible—or perhaps one of the characters is intentionally lying. This approach reflects the idea that truth is subjective and can vary depending on the "color of the glass" through which it is viewed, as expressed in Ramón de Campoamor's quatrain:

> *"In this treacherous world, nothing is true or false; everything depends on the color of the glass through which one looks."*

Origin of the Term 'Rashomon Effect'

The term Rashomon Effect comes from the film *Rashōmon*, directed by Akira Kurosawa in 1950 and based on two short stories by Ryūnosuke Akutagawa: *Rashōmon* and *In a Grove*. The film tells the story of the death of a samurai and the rape of his wife in 12th-century Japan, presenting these events through the different accounts of those involved, shown via flashbacks.

Each of these accounts is framed as a "story within a story," meaning that the characters narrate events from their own perspectives, enhancing the apparent realism of each version. However, the film does not present any version as the definitive truth. On the contrary, *Rashōmon* demonstrates that each account is true in its own way, shaped by the context, background, and circumstances of the narrator.

The film pioneered the non-linear, kaleidoscopic narrative structure, which has since become widely used in contemporary storytelling. In this structure, each narrator provides a piece of information that may or may not be completed by other perspectives. While this technique is challenging to implement across an entire TV series—where it would become a defining part of the format rather than a special feature—it has been successfully used in many individual episodes, both in comedy and drama.

Examples of the Rashomon Effect in Television

A comedic example of the Rashomon Effect appears in *How I Met Your Mother* (Season 3), where the four main characters provide conflicting accounts of how they first met. In drama, the series *Lost* offers flashbacks of Sun and Jin, showing how they perceive the same events differently, adding depth to their characters and relationship.

While it is uncommon to build an entire series around the Rashomon structure, one notable exception is *The Affair*, created by Sarah Treem and Hagai Levi. In an interview, Treem explained that Levi—who previously created *In Treatment* in Israel—sees himself as a format creator, focusing more on the framework of the story than on individual script details. In *The Affair*, they decided to adopt a Rashomon structure for every episode. Two characters recount the same events from their distinct perspectives, offering contrasting versions of what happened, leaving the audience to interpret which, if any, version is closer to the truth.

How to Use the Rashomon Effect in Our Stories

If you want to create a story with **multiple points of view**, follow these steps:

1. Create the Base Story

The first step is to develop the core story. It should involve some conflict or friction to allow for different perspectives to emerge.

- **Example from *Rashōmon*:** In 12th-century Kyoto, under the ruined gates of the Rashomon temple, a woodcutter, a Buddhist priest, and a pilgrim take shelter from torrential rain. They discuss the trial of a bandit accused of killing a feudal lord and raping his wife.
- **Example from *The Affair*:** The show follows the emotional consequences of an extramarital affair between Noah, a high school teacher in New York, and Alison, a waitress in Montauk, Long Island. Noah is married with four children but feels frustrated by his dependence on his father-in-law. Alison, meanwhile, is trying to rebuild her life and marriage after the death of her son.

2. Decide on the Protagonists and Points of View

Once the story is defined, determine which characters will narrate it. This may seem straightforward, but it requires careful consideration.

- In Kurosawa's *Rashōmon*, the original short story featured seven witnesses, but the film reduces this to four key narrators:
 - The Wife: Provides her version of the crime and the rape.
 - The Bandit: Describes the fight and claims the wife submitted willingly.
 - The Murdered Man: Speaks through a medium, recounting betrayal and death.
 - A Witness: Offers initial context and later provides a surprising conclusion.
- In *The Affair*, the focus is on Noah and Alison, with both sharing their perspectives on the romance. In later seasons, the narrative expands to include Cole and Helen, the spouses affected by the affair, adding more complexity and depth. By the third season, a fifth narrator is introduced, further diversifying the narrative.

3. Divide the Story into Versions and Points of View

Next, decide which parts of the story each character will narrate and how they will present their version. The Rashomon structure doesn't function like a puzzle where each narrator fills in gaps; instead, it involves overlapping stories, with each character presenting the same events from their own perspective.

The idea behind *Rashōmon* is that it's impossible to arrive at an absolute truth through storytelling. It is up to the reader or viewer to piece together a plausible reality based on the various points of view.

4. Decide the Order of the Narrative

The sequence in which narrators tell their stories is critical, as it shapes how the audience understands the plot. The first narrator establishes the initial framework, followed by other narrators who either expand or contradict the previous version. This creates doubt and forces the audience to question what they've seen or heard.

- In *The Affair*, the first episode starts with Noah's point of view, portraying Alison as a stereotypical seductive waitress. However, when Alison's version follows, it challenges Noah's portrayal, revealing a more nuanced perspective. Had the story started with Alison's version, the narrative effect would have been completely different. As the saying goes, "the order of the factors affects the product."

Each narrator's account introduces a twist that reshapes the audience's understanding. This narrative technique is powerful because each version has its own beginning, middle, and end, creating turning points as new perspectives emerge.

5. Use According to Genre

The Rashomon Effect can be applied across different genres, each adapting it to suit its narrative goals:

- **Comedy**
 Shows like *Arrested Development, Frasier, Everybody Loves Raymond, 30 Rock,* and *The Fresh Prince of Bel-Air* use multiple perspectives to highlight the subjectivity of each character. Through misunderstandings, contradictions, and humorous surprises, these comedies entertain the audience by exposing the characters' biases and flawed interpretations.

- **Drama**
 In drama, the Rashomon structure allows different points of view to intensify conflict or reveal new layers of meaning. Besides *The Affair*, examples include the *ER* episode *Four Corners* and *CSI: Crime Scene Investigation*'s episode *Rashomama*. Here, the audience isn't searching for a definitive truth but instead seeks to understand each character's perspective and how it shapes their actions. In TV dramas, viewers already know the characters and enjoy seeing if they react in ways consistent with their established personalities.

- **Thriller or Mystery**
 In thrillers, the Rashomon Effect is often used to unravel clues and solve mysteries. A good example is the penultimate episode of *Veronica Mars* (Season 1). In this teen mystery series, Veronica pieces together witness testimonies to solve one of the season's central mysteries. The audience follows her as she analyzes grudges, biases, and inconsistencies in the witnesses' accounts to uncover the truth.

Occam's Razor

> *The translation of "Pluralitas non est ponenda sine necessitate",*
> *is "Plurality should not be posited without necessity"*
> *William of Ockham*

Occam's Razor is a philosophical and methodological principle named after William of Ockham (1285-1349), an English friar, theologian, and philosopher. This principle can be summarized as: "the simplest explanation is usually the correct one." In other words, when several possible explanations exist for a phenomenon, the simplest one—the one that makes the fewest assumptions and involves the least complexity—is often the best starting point.

Occam's Razor is applied across various fields, including science, philosophy, and medicine, helping researchers focus on the most probable theories and avoid unnecessary complexity. However, it's important to note that the simplest explanation isn't always correct. Complex solutions can sometimes turn out to be the right ones. Nonetheless, Occam's Razor serves as a valuable guideline for starting investigations and forming hypotheses. As screenwriters, we can also use it to simplify and sharpen our stories.

Origin of Occam's Razor

William of Ockham did not explicitly formulate the principle in the way we know it today. However, it is attributed to him because of his consistent use of simplicity in his philosophical and theological arguments. Ockham preferred to eliminate unnecessary concepts and abstractions, favoring a minimalist approach to reasoning.

While similar ideas had existed since Aristotle and other ancient thinkers, Ockham applied them more rigorously in his work, which is why the principle now bears his name. The term 'razor' is used metaphorically to indicate that this principle "cuts away" unnecessary complexity, leaving only the essential elements needed to explain a phenomenon.

Examples of Occam's Razor in Movies and Books

Sherlock Holmes and The Hound of the Baskervilles: In Sir Arthur Conan Doyle's *The Hound of the Baskervilles,* Holmes investigates what seems to be a supernatural curse involving a spectral hound. Despite the eerie atmosphere and rumors, Holmes dismisses supernatural explanations and focuses on logical reasoning. Eventually, he uncovers that the hound is a real dog, coated with phosphorescent material to give it a ghostly appearance, used as part of a plot to claim an inheritance. Holmes's solution, though still complex, avoids the supernatural and aligns with the principle of Occam's Razor.

The Sixth Sense (M. Night Shyamalan): Throughout *The Sixth Sense,* Dr. Malcolm Crowe tries to help a boy who claims to see dead people. The final twist reveals that Crowe himself is a ghost, elegantly explaining his strange interactions with the world. While various complex theories could have been formulated to explain Crowe's experiences, the

truth—though surprising—proves to be the simplest explanation, tying together all the narrative threads.

Gravity (Alfonso Cuarón): In *Gravity*, astronaut Ryan Stone finds herself stranded in space after her shuttle is destroyed. Instead of devising a complex plan or waiting for an unlikely rescue, she uses the available resources to propel herself toward a Chinese space capsule, ultimately ensuring her survival. This direct and feasible solution exemplifies Occam's Razor—opting for simplicity and practicality in a life-or-death situation.

The Martian (Andy Weir): In *The Martian*, astronaut Mark Watney is stranded on Mars. Faced with limited resources, he applies basic scientific principles to solve his problems, such as growing potatoes using Martian soil and repurposing equipment to communicate with Earth. His reliance on simple, science-based solutions exemplifies the effectiveness of Occam's Razor in overcoming complex challenges.

And Then There Were None (Agatha Christie): In Agatha Christie's *And Then There Were None* (known in Spanish as *Diez Negritos*), ten individuals are invited to an island, where they begin to die one by one, following the pattern of an eerie nursery rhyme. Throughout the novel, various complex theories are proposed, ranging from conspiracies to collective madness. However, the truth is revealed to be simple: one person is systematically killing the others according to a meticulously planned scheme. The resolution aligns with Occam's Razor, as the simplest explanation—a single killer—is the correct one.

Breaking Bad (Vince Gilligan): In *Breaking Bad*, Walter White, a high school chemistry teacher diagnosed with terminal cancer, turns to drug production to secure his family's financial future. Instead of pursuing complex or risky alternatives, Walter uses his expertise in chemistry to produce methamphetamine. This decision, though morally questionable, exemplifies Occam's Razor by being a practical solution to his financial

problems. However, this seemingly simple solution triggers a series of escalating events that form the backbone of the series' narrative.

How to Use Occam's Razor to Simplify the Structure of a Script

Occam's Razor can be a powerful tool to streamline the structure of your script and make it more efficient. Here are some ways to apply it:

1. **Evaluate the Subplots**

Review each subplot and ask yourself if it truly adds value to the main story. If a subplot doesn't contribute to the evolution of the main plot or character development, consider eliminating it or merging it with another subplot that does.

2. **Simplify Character Relationships**

Screenwriters sometimes create complex networks of relationships that can confuse the audience. Use Occam's Razor to determine whether all these relationships are necessary for advancing the plot and developing the characters. If not, simplify or remove some to maintain narrative clarity.

3. **Reduce the Number of Characters**

If multiple characters serve similar functions within the story, consider combining them into a single character who fulfills all those roles. Make sure this doesn't overwhelm the character or compromise their believability.

4. **Clarify the Plot**

Eliminate unnecessary plot twists or revelations that don't align with the main objective of the story. Following Chekhov's Gun, every element should have a clear purpose—whether it's to move the plot forward, reveal character traits, or maintain narrative consistency.

5. **Focus the Characters' Objectives**

Ensure that your characters' goals are clear and not diluted by too many secondary objectives or conflicting motivations. A strong, singular goal is often more effective than multiple, weaker ones.

6. **Optimize Exposition**

Instead of relying on long exposition scenes or complex dialogues to explain the plot, look for simpler, more organic ways to reveal key information through action and character interactions.

7. **Review the Structure Act by Act**

Ensure that each act (beginning, middle, and end) is essential and free of unnecessary elements. Every scene and moment should contribute to the story's progression and development.

8. **Minimize Locations or Settings**

If your script has multiple locations that serve similar functions, consider consolidating them into one. Fewer locations can help maintain narrative focus and reduce production complexity.

Simplicity Does Not Mean Losing Depth

When applying Occam's Razor, remember that simplicity does not mean sacrificing the depth or richness of your narrative. Simplicity implies efficiency and clarity, allowing the story to flow naturally while maintaining its emotional complexity and thematic impact.

Unreliable Narrator

The greatest trick the devil ever pulled was convincing the world he didn't exist.

Verbal

(The Usual Suspects)

An unreliable narrator is one who loses credibility throughout the story, leading the audience to question the truth of the events being told. This narrative strategy, used in both literature and audiovisual media, adds depth and complexity to the plot. It requires the audience to actively engage, piecing together information to distinguish between what is real and what is deceptive.

Sometimes the unreliable nature of the narrator is subtly clear from the start, even if only on an unconscious level. Other times, the deception is hidden, with small clues scattered throughout the narrative, only revealing the truth in a final twist. This latter approach carries risks, as the audience may feel betrayed if the reveal feels unjustified. However, when executed well, it can deliver spectacular narrative impact.

In real life, we encounter liars, manipulators, and unreliable individuals without always realizing it. Fiction reflects this same

unpredictability, which is why unreliable narrators feature prominently in twisted plots—their missing pieces shape the final revelation. The moment the truth emerges changes how the audience understands everything that came before, making the plot twist feel satisfying.

Why Is This Narrator Unreliable?

In essence, an unreliable narrator lies—whether deliberately or unintentionally. The reasons behind the deception can vary. They may lie to hide something, but sometimes they are simply unaware of the truth due to ignorance, mental instability, intoxication, or exhaustion. Regardless of the cause, what makes these narratives captivating is that they withhold key information, leaving room for surprise. Below, we explore the different ways a narrator can be unreliable.

1. Deliberate Lies

Some narrators lie intentionally to serve their own interests. People lie for many reasons: to look good, make excuses, get what they want, avoid punishment, delay decisions, or out of fear of rejection. These lies can also serve as survival tactics.

Verbal Kint in *The Usual Suspects*

Verbal Kint, a small-time criminal, is the only survivor of an explosion on a ship. During his police interrogation, he weaves an intricate tale about his involvement with four other criminals and the legendary crime lord Keyser Söze. Verbal's entire story is told orally, making it easy for him to fabricate details. After being released, the detective realizes that Verbal constructed his story using elements from the interrogation room. The big twist reveals that everything he said was a lie—though the true nature of the final revelation is even more shocking.

Pi in *Life of Pi*

Pi is an embellisher—a narrator who adds fantastical elements to his stories for entertainment. In his account of survival at sea, Pi tells a series of events so incredible that the audience wants to believe them, even though they suspect they aren't true. His storytelling becomes a collaborative deception—we, as the audience, willingly engage with the lie because the truth is too harsh to accept. The final twist, which reveals the grimmer reality behind his story, still manages to surprise us.

Ted in *How I Met Your Mother*

Ted Mosby serves as an unreliable narrator in this comedy series, often distorting events to suit his perspective. The show plays with misunderstandings and exaggerations, highlighting how Ted's recollections are inconsistent or biased. This creates humorous moments, as Ted narrates things he couldn't have known or misremembers details.

2. Unintentional Lies

Some unreliable narrators don't lie on purpose—they simply lack the necessary information to tell the full story. In such cases, the audience must detect the narrator's limitations and understand that the story being told is incomplete or skewed.

- **The Rashomon Effect**
 The Rashomon effect occurs when an event is recounted from multiple perspectives, each presenting a different version of the truth. The audience must compare these perspectives to discern what really happened, realizing that each narrator provides only a partial truth.
- **Mental Illness and Altered Perception**
 Some narrators are unreliable because their mental faculties are impaired. They may suffer from trauma, mental illness,

intoxication, or exhaustion, which skews their perception of reality.

Charlie in *The Perks of Being a Wallflower*

Charlie, a high school freshman, struggles with repressed memories of his abusive aunt. Throughout the film, he recalls her affectionately, but something about these memories feels off. The final revelation—that his aunt abused him—reframes the entire narrative. We realize that Charlie's mind repressed the truth as a way of protecting him from trauma.

Awake

In *Awake*, the protagonist lives in two parallel realities, unsure which one is real. As details overlap between the two worlds, he begins to question his sanity. The fragmented narrative reflects his disturbed mental state, making every plot point potentially false or distorted.

Jack in *Fight Club*

Jack, the protagonist of *Fight Club*, suffers from insomnia, which causes memory lapses and leaves him unaware of what he does during lost hours. The final twist reveals that Jack's alter ego, Tyler Durden, has been using their shared body to create chaos. Jack believed he was resting, but Tyler was acting in his place. This dual identity is revealed only at the end, leaving both Jack and the audience stunned.

The unreliable narrator creates stories filled with ambiguity and surprise, challenging the audience to interpret events carefully. Whether the narrator lies deliberately or unintentionally, their gaps and distortions pave the way for unexpected twists that reshape the narrative. These narrators add complexity to the storytelling, forcing the audience to question what they see and reassess the truth when the final revelation is unveiled.

How to Write a Narrator We Can't Trust

If you want to incorporate an **unreliable narrator** into your story, follow these steps:

1. Define the Reason for Their Unreliability

First, clarify why the narrator will be unreliable. Are they lying deliberately? If so, what's their motive? Do they lie to gain something, avoid punishment, protect their image, or embellish the story?

Alternatively, the narrator might not be lying on purpose. Are they mentally unstable, perceiving reality differently? Are they intoxicated or suffering from amnesia or trauma? Could they be naïve or socially inept, narrating events from an eccentric point of view? Or perhaps they are manipulative, distorting reality for personal gain.

2. Create the True Story

Once the reason for the narrator's unreliability is clear, develop the real story—the events that actually happen in the protagonist's world. This serves as the underlying narrative that will be altered by the unreliable narrator. Following Ricardo Piglia's idea from *Thesis on the Short Story*, this would be the visible, canonical narrative presented to the audience.

3. Invent the False Story

The unreliable narrator hides or distorts the truth, offering a false version of events. This false narrative will withhold key information, which the audience will discover in the final revelation.

Use brainstorming techniques to generate different ways your narrator can conceal critical details. Don't judge ideas at this stage—just create options. Later, you can refine and select the most fitting elements for your story.

4. Plant Subtle Clues

Even though the narrator presents a coherent version of events, subtle clues should hint that something is off. These clues might include:

- **Minor contradictions** in the narrator's story.
- **Suspicious reactions** from other characters toward the narrator.
- **Inconsistent behavior**, such as shifts in tone or erratic actions.
- **Visual or auditory elements** (in screenplays) that subtly contradict the narrator's words.

5. Determine the Level of Credibility Throughout the Story

Decide how much the audience will trust the narrator at different points in the story. Will the audience gradually suspect the narrator's deceit, or will the truth only be revealed at the very end?

- If you aim for a final twist, the clues should be subtle.
- If you want the audience to doubt the narrator from the start, the clues can be more evident.

In *The Sixth Sense*, the narrator (Dr. Malcolm Crowe) appears trustworthy. There are no obvious hints to suggest that he's dead. This makes the final revelation all the more impactful, as neither the audience nor Crowe himself knew the truth.

Exercise: Write down ten ways to hint that your narrator can't be trusted. Use these ideas to design how your script will reveal the narrator's unreliability.

6. Keep the Audience Engaged in the Narrator's Perspective

Even if the audience begins to doubt the narrator, they must remain engaged in their point of view. Here are some strategies to achieve that:

- **Use First-Person or Close Narration:**
 First-person narration creates intimacy with the narrator, limiting what the audience knows to their perspective. Alternatively, a limited third-person perspective can also control the information provided.
- **Skew the Information:**
 Gradually reveal key details. The narrator might hide facts to protect themselves or manipulate the truth. Let the audience slowly piece together the real story.
- **Provide Credible Justifications:**
 Give the narrator logical reasons for their actions or interpretations. Even as inconsistencies arise, the audience should feel tempted to believe the narrator.
- **Blur the Line Between Reality and Imagination:**
 Use distorted perspectives to confuse what's real and what's imagined. This creates tension and aligns the audience's confusion with the narrator's.

7. Balance Empathy and Distrust

A successful unreliable narrator must evoke both empathy and doubt. The audience should care about the narrator, even if they recognize they aren't fully trustworthy.

- **Make the Narrator Relatable:**
 Give the narrator understandable motivations—such as fear, love, or survival—that justify their actions. The audience is more likely to forgive their deceit if they understand the reasons behind it.

- **Let Doubt Build Slowly:**
 Don't reveal the narrator's unreliability right away. Use small inconsistencies and strange behaviors to plant doubt. This gradual approach keeps the audience engaged, trying to figure out what's real and what isn't.

8. Use the Plot Twist as a Reward

A well-executed plot twist can transform the entire narrative. To make it effective:

- **Plant Clues Early:**
 If the twist reveals the narrator as unreliable, the audience should be able to look back and find subtle hints. This ensures the twist feels fair rather than a cheap trick.
- **Make the Twist Inevitable but Unexpected:**
 The twist should feel like the only possible outcome, even if the audience didn't see it coming. Upon reflection, the clues should be obvious, but not so blatant that they ruin the surprise.

The Bookending Technique

Rosebud...

Charles Foster Kane

(Citizen Kane)

The bookending technique is a framing device used across various storytelling forms, including film, television, poetry, and novels. As its name suggests, **it wraps the narrative with two mirrored scenes—one at the beginning and one at the end**—like a pair of bookends. By linking the opening and closing moments, this technique provides the story with cohesion and thematic coherence.

Bookending often highlights the character's essential journey, showing where they begin and where they end, thus emphasizing their transformation. It offers a way to conclude the narrative satisfyingly by reminding the audience how it all started. This full-circle structure provides a sense of closure and encourages the audience to reflect on the events that occurred between the two points. Additionally, the technique adds structure to the narrative by clearly marking the beginning and the end.

The bookending technique shares similarities with other narrative devices, such as circular storytelling and frame stories.

- **Circular Storytelling**

Circular storytelling is a structure where the protagonist returns to the place where the story began, reflecting their internal growth. While the setting or circumstances may appear unchanged, the character's transformation is the focal point.

Example: *Parasite*

In *Parasite*, the protagonist family infiltrates the home of a

wealthy family, only to be forced back to the basement where they originally lived. Although their circumstances seem similar to where they started, they have lost loved ones and realized the futility of escaping their social class. The return to the basement serves as a powerful reflection of their tragic journey and newfound understanding.

- **Frame Stories**

A frame story surrounds or encloses another narrative, providing context and key information to guide the interpretation of the inner story. The frame typically appears at both the beginning and end, acting as a narrative anchor.

Example: *One Thousand and One Nights*
The most famous example is *One Thousand and One Nights*, where the frame story revolves around Scheherazade's effort to delay her execution by telling a series of captivating tales to the king.

Example: *The Princess Bride*
In *The Princess Bride*, a grandfather reads a fantasy tale to his sick grandson to cheer him up. The fantasy narrative unfolds within the frame of this interaction, offering emotional resonance by linking the fictional adventure to their real-world bond.

Example: *Forrest Gump*
In *Forrest Gump*, the protagonist recounts the story of his life from childhood to adulthood while sitting on a park bench. The frame narrative provides context for the events we see, and the simplicity of the framing scene emphasizes the significance of Forrest's journey.

How to Apply the Bookending Technique

1. Mirror Bookends

There are different ways to use the bookending technique, depending on the relationship between the two 'bookends.' The most common approach is when the second bookend mirrors the first with subtle changes, reflecting the protagonist's evolution throughout the story.

Example: *1917*
In Sam Mendes' World War I epic, the protagonist Will Schofield starts his mission by sleeping against a tree. After completing his dangerous journey, he returns to rest against another tree, symbolizing both closure and exhaustion.
This framing encapsulates the hero's journey, beginning with the call to action and ending with a moment of respite. Though Will starts and ends in seemingly the same place, he is deeply transformed by his experience, trapped in the endless cycle of war.

Alternatively, the second bookend can continue the first, providing closure to an unfinished story. Examples of this can be found in *Citizen Kane* and *Pulp Fiction*, where the final scenes complete the narratives initiated in their opening sequences.

2. Size of the Bookends

The size of the bookends can vary—from a single image to a full scene.

Example: *Lost*
In the pilot episode of *Lost*, the story begins with a close-up of Jack's eye as he wakes up on a deserted island after a plane crash. 121 episodes later, the series ends with the same character's eye closing, marking the end of his journey and symbolizing the show's conclusion.

3. Relationship Between Bookends and the Central Story

Bookends often feature main characters and serve to highlight their development. However, some stories use parallel narratives with different characters that reflect similar themes.

Example: *Pulp Fiction*

The film opens with two criminals planning a diner robbery and closes with the same scene, completing the interrupted heist. This framing introduces the film's world of crime and returns to it at the end.

Among the patrons are two key characters, Jules and Vincent, whose contrasting fates reflect the film's central theme. Jules undergoes a transformation after surviving a near-death experience, deciding to leave his life of crime, while Vincent ignores the lesson and ultimately pays with his life.

4. The Function of Bookends

- **Introduction of Essential Elements:**
 The first bookend establishes the main characters, setting, and themes while introducing a sense of intrigue that unfolds throughout the narrative.

 ### Example: *The Godfather Part II*

 The film opens with Michael Corleone reflecting on his role as the head of the mafia. Having reluctantly taken power in the first film, Michael now grapples with whether he can maintain control and protect his family.

- **Resolution and Closure:**
 The final bookend provides closure by addressing the themes and conflicts introduced at the beginning.

Example: *The Godfather Part II*

The film ends with Michael once again deep in thought. However, by this point, it's clear he has fully embraced his dark side, even murdering his brother to retain power. His transformation is complete, and his moral descent is irreversible.

5. Uses of Bookends

A. To Highlight a Character's Evolution

Bookends are often used to showcase the protagonist's transformation by returning to a similar situation at the end, allowing the audience to reflect on how much has changed.

Example: *Whiplash*

At the beginning of *Whiplash*, the protagonist practices the drums alone in a dim, cold setting. By the film's end, he performs on stage in front of an enthusiastic audience, finally earning the approval of his mentor. The contrast in lighting and environment between the two scenes—cold blue at the beginning, warm golden tones at the end—emphasizes the character's growth through sacrifice and dedication.

B. To Indicate the Theme

The first bookend can introduce the central theme of the narrative, which is then revisited at the end.

Example: *Forrest Gump*

The film opens with Forrest sitting on a bench, watching a feather drift in the wind. The same feather reappears at the end, symbolizing Forrest's passive approach to life—accepting whatever comes his way without resistance. The bookends reinforce the idea that, like the feather, Forrest lets life carry him along for better or worse.

C. To Solve a Mystery

Bookends can also be used to **create and resolve a mystery**, providing a satisfying narrative arc.

Example: *Citizen Kane*

The film opens with Charles Foster Kane uttering his last word, "Rosebud," and dropping a snow globe as he dies. Throughout the story, a journalist investigates Kane's life, trying to uncover the meaning of that mysterious word.

In the final scene, the bookend comes full circle: Kane's childhood sled, with the word "Rosebud" inscribed on it, is tossed into a furnace. The audience now understands that Rosebud symbolized the lost innocence Kane longed for throughout his life.

D. To Show a Shift in Power

Bookends can highlight power dynamics that change significantly over the course of the story.

Example: *Gone Girl*

The film opens and closes with the same image: Amy Dunne resting her head on Nick's chest as he strokes her hair. However, by the end, the power dynamic between them has drastically shifted. In the opening scene, Nick strokes Amy's hair absentmindedly, musing about "cracking open her skull to see what she's thinking." By the end, Nick's hand is tense and unwilling, while Amy presses her head firmly against him, forcing him to continue the gesture. This final scene reflects Amy's complete control over Nick, symbolizing the toxic relationship they've entered.

E. To Convey Dramatic Irony

The contrast between the first and final bookend can create dramatic irony, where the audience knows more than the characters about what has truly changed.

Example: *The Truman Show*

The film begins with Truman stepping out of his house, cheerfully delivering his signature line: "In case I don't see you, good afternoon, good evening, and good night." At the end, as Truman prepares to leave the artificial world created for him, he looks directly at the camera and delivers the same line. However, this time, the meaning has changed. Truman is no longer a prisoner of voyeuristic entertainment—he acts freely and on his own terms.

Chinese Boxes

Then King Shahryar said to her:

"Hurry, then, and tell them to me!"

And Scheherazade promised him for the next night.

One Thousand and One Nights

The Chinese box technique—also known as Russian dolls or framed storytelling—involves embedding one story within another, and so on, in successive layers. This method is reminiscent of classical works such as *Don Quixote* or *One Thousand and One Nights*, where intertwined stories unfold, and once they conclude, the narration returns to the original or main plot.

A character might recount the story of someone else, who in turn narrates another event involving yet another person, creating a multi-layered exchange of places, events, and time periods. This structure often blends the present with the past and future, challenging the audience to follow these shifts.

This is an ancient narrative device used in epic tales such as *The Epic of Gilgamesh* from Mesopotamia and Indian works like the *Vedas* and

the *Mahabharata*. The Greeks and Romans also employed it, as seen in *The Golden Ass* by Apuleius, where the protagonist listens to the story of a captive woman recounting the myth of Cupid and Psyche, which she herself had heard during her captivity.

Examples in Classic Literature

One Thousand and One Nights

In this collection of traditional Middle Eastern tales, one story emerges from another. The narrator, Scheherazade, tells the Sultan a new tale every night to avoid execution. She skillfully pauses each story at a cliffhanger, leaving the Sultan intrigued and granting herself another day of life. Eventually, the Sultan forgives her, and she survives for a thousand and one nights through the power of her storytelling.

Don Quixote de la Mancha

In Cervantes' novel, the Chinese box structure is used to introduce side stories through the voices of Sancho, other characters, or the omniscient narrator. These tales include complete narratives like *The Captive Captain* and *The Impertinent Curious Man*, which are interwoven into the main plot.

How Chinese Boxes Work

The Chinese box structure functions metaphorically, where one story unfolds to reveal another within. The narrative layers often reflect each other, and the listener or listeners within the story play a crucial role. These internal audiences serve as mirrors for the real audience, and their reactions or decisions may influence the direction of the storytelling.

Mario Vargas Llosa explains this concept well:

"Between the reader and the narrative material, an intermediary arises: the objective level disappears, crossed by a subjective level through which the material passes before reaching the reader. In this transition, the material inevitably undergoes changes, acquiring emotional elements that are not its own but belong to the intermediary. This subtle blend is one of the oldest tools of the novel, which could be called the 'Chinese box.' The Chinese box is also one of the most common techniques in modern novels, where the intermediary, the witness, becomes an essential character: they establish the ambiguity and complexity of the narrative, multiplying perspectives and imbuing the events of the fiction with subjective depth."

Mise en Abyme vs. Chinese Boxes

A concept closely related to Chinese boxes is mise en abyme, which literally means "placed into the abyss." While both techniques involve stories within stories, the key difference is that mise en abyme embeds a story that mirrors or shares the same theme as the main narrative.

- In **mise en abyme**, the embedded narrative creates a reflection of the original, often repeating themes or motifs. This reflection can occur once, multiple times, or infinitely, much like an object reflected between two mirrors, generating the impression of an endless visual abyss.
- **Chinese boxes**, on the other hand, focus more on narrative layering without necessarily requiring thematic repetition. The main goal of Chinese boxes is to explore perspectives and subjective interpretations, often enriching the story with ambiguity and emotional depth.

The Chinese box technique is a powerful narrative tool that creates complex, layered storytelling by embedding stories within stories. It challenges the audience to follow shifting timelines and perspectives, while

also inviting them to reflect on the subjectivity of narration. This technique has remained relevant through the centuries, influencing not only epic tales and classical literature but also modern novels and films. Whether used to add depth, suspense, or ambiguity, Chinese boxes allow storytellers to explore the multiplicity of truth and the intricate relationship between storytellers, listeners, and reality.

How to Use Chinese Boxes and Mise en Abîme in Cinema

1. The Number of Stories

The first step is to define how many embedded stories will be included within the main narrative. There can be one or multiple layers, with more stories evoking the sensation of Chinese boxes, each one revealing another within.

> **Literary Examples:**
> A common scenario involves characters gathering to tell and listen to stories. In *One Thousand and One Nights*, Queen Scheherazade tells a series of fantastic tales to her husband, the Sultan, across many nights. Some of these stories contain further embedded narratives, such as the adventures of Sinbad the Sailor.
>
> Similarly, in *The Canterbury Tales*, a group of pilgrims passes the time by organizing a storytelling contest during their journey to Canterbury. In The Decameron by Boccaccio, young aristocrats escape a plague-ridden city to a countryside villa, where they entertain themselves by sharing stories.

2. Connections to the Main Story

One of the appealing aspects of Chinese boxes is that the embedded stories don't need to be connected in plot, characters, tone, or

atmosphere with the primary narrative. These stories can introduce dynamism, surprise, and mystery, enriching the viewing experience through diversity.

However, when the embedded narratives are more closely linked to the main plot, we approach the mise en abîme technique. In these cases, the embedded stories reflect or parallel the primary narrative, creating thematic resonance and interconnection. This deepens the story's meaning by highlighting key motifs or exploring similar conflicts.

3. The Size of the Embedded Story

The length of the embedded narrative can vary, depending on the importance it holds within the overall structure. Sometimes, the main plot dominates, with the embedded story serving only as a brief but meaningful digression.

> **Example:** In *Pulp Fiction*, Butch's father's comrade tells a short but impactful story about how his father preserved a family heirloom—a gold watch—through generations. This brief story adds depth to Butch's character and connects to his later actions.

Alternatively, the main narrative can serve as a framework for multiple secondary stories that take up most of the work.

> **Examples:**

In *The Princess Bride*, a **grandfather reads a fantasy tale** to his grandson, which becomes the central focus of the film.

In *Big Fish*, a son recalls **his father's extraordinary stories** on his deathbed, blurring the line between reality and fiction.

In *Forrest Gump*, the protagonist recounts **his life story** to various strangers at a bus stop, framing the narrative through these conversations.

4. Vicarious Narration

This technique allows the narrator to reveal information indirectly by embedding it within another story. The narrator uses a story within the story to convey a message, idea, or emotion they are unwilling to state explicitly. This layer of storytelling adds subtlety and depth to the narrative, requiring the audience to interpret the underlying meaning.

5. Film within a Film

An application of mise en abîme in cinema is the "film within a film" device, where a movie contains a storyline about the making of another film. This technique allows the embedded film's narrative to reflect or mirror the primary film through its mise-en-scène.

> **How It Works:** The audience sees the production process: filmmakers at work, actors preparing for scenes, and directors solving challenges. The plot of the embedded film may directly parallel the main film's narrative, creating a sense of symmetry and reflection.

> **Example:** In François Truffaut's *La nuit américaine* (*Day for Night*), the film explores the process of making a movie, blending reality with fiction. The characters' personal lives and the film they are producing intertwine, highlighting how art reflects life and vice versa.

PLOT TROPES

MacGuffin

In crime stories, it's almost always the necklace, and in spy stories, it's almost always the papers.

Alfred Hitchcock

The MacGuffin is a narrative device used in film to drive the plot forward. While the term might sound complex, it was first introduced in 1939 by screenwriter Angus MacPhail and later popularized by director Alfred Hitchcock.

Angus MacPhail, an English screenwriter active since the late 1920s, is remembered for his collaborations with Hitchcock. According to Ivor Montagu, who worked with Hitchcock on several British films, MacPhail coined the term MacGuffin, which Hitchcock later adopted and incorporated into his storytelling. One of the earliest uses of this concept was in Hitchcock's *The 39 Steps*, where the MacGuffin takes the form of military secrets.

Hitchcock explained the idea during a 1939 lecture at Columbia University in New York City:

"It could be a Scottish name, taken from a story about two men on a train. One man says: 'What's that package up there in the luggage rack?' The other answers: 'Oh, that's a MacGuffin.' The first man asks: 'What's a MacGuffin?' 'Well,' the other man says, 'it's an apparatus for trapping lions in the Scottish Highlands.' The first man says, 'But there are no lions in the Scottish Highlands.' And the other replies, 'Well, then, that's no MacGuffin!' So you see, a MacGuffin is really nothing at all."

Although Hitchcock and MacPhail popularized the MacGuffin, the concept had precedents in earlier cinema. For example, silent film actress Pearl White starred in several suspense serials, such as *The Perils of Pauline*, where characters spent most of their time chasing objects of dubious importance, such as a film reel. These objects were essential to the plot, even if their significance was never explained. White reportedly referred to these objects as "weenies," using the term in much the same way Hitchcock would later use MacGuffin.

A MacGuffin can be an object, person, or situation that propels the story forward. It can take the form of anything—a suitcase full of cash, a stolen computer chip, or a hidden artifact. However, the true value of the MacGuffin lies not in its significance to the audience but in its importance to the characters within the story.

One reason the MacGuffin remains a powerful storytelling tool is that it serves as a catalyst for the characters' actions and decisions. The pursuit of the MacGuffin often leads to situations of danger, comedy, tension, or drama, shaping the narrative even if the object itself is not crucial to the story's resolution.

Typically, the MacGuffin is introduced early in the narrative, and much of the story revolves around characters trying to obtain, protect, or recover it. This pursuit helps build tension and suspense, keeping the audience engaged as the plot unfolds. While the MacGuffin might seem

insignificant by the end of the story, its true purpose lies in fueling character dynamics and moving the plot forward.

Examples of MacGuffins in Cinema

A classic example of a MacGuffin is the Maltese Falcon statuette in John Huston's *The Maltese Falcon*. The characters relentlessly pursue the statuette, believing it holds the key to their personal success. However, by the end of the film, it's revealed that the object has no intrinsic value—its significance lies only in how it drives the characters' actions and motivations throughout the story.

At the beginning of *Citizen Kane*, the dying Charles Foster Kane utters the cryptic word "Rosebud." No one knows what it refers to, and the search for its meaning prompts an investigation into Kane's entire life. In the end, the mystery is solved: Rosebud was the name of his childhood sled. While the sled holds little narrative relevance in the grand scheme of the plot, it serves as a symbolic thread, offering insight into Kane's emotional longing and adding cohesion to the story.

One of the most famous MacGuffins in modern cinema is the briefcase belonging to Marsellus Wallace in *Pulp Fiction*. The glowing contents inside the briefcase are never revealed to the audience, yet its pursuit serves as the catalyst for several key events in the film. The briefcase motivates the characters' actions, but its contents are ultimately irrelevant to the resolution of the story.

In the Coen brothers' *No Country for Old Men*, a desperate man named Llewelyn Moss stumbles upon a suitcase filled with money at the site of a drug deal gone wrong. His possession of the suitcase sets off a chain of violent events, with a ruthless assassin named Anton Chigurh relentlessly pursuing him. However, Chigurh is not after the money, and the sheriff investigating the murders never fully understands the motivations behind the bloodshed. The money serves as a MacGuffin,

driving the narrative forward but ultimately holding no meaning to the story's deeper themes of fate, violence, and morality.

In a 1977 interview with Rolling Stone, George Lucas identified the Death Star plans as a MacGuffin in *Star Wars: A New Hope*. Lucas explained:

> "The main object doesn't matter in and of itself; it's simply the catalyst for action."

The Death Star plans are not important for what they are, but for what they represent: a chance to destroy the Empire's most powerful weapon and defeat Darth Vader. The pursuit of the plans drives the plot, but their role is purely functional—they exist to move the characters toward larger narrative goals.

The MacGuffin in Other Narrative Media

The MacGuffin isn't exclusive to cinema—it's also a valuable narrative tool in literature, video games, and other media. In mystery novels, the MacGuffin may be a valuable object or crucial piece of information that drives the plot forward. For example, in *The Da Vinci Code* by Dan Brown, the Holy Grail serves as the MacGuffin that the protagonist seeks to uncover.

In *The Lord of the Rings* by J.R.R. Tolkien, the One Ring is a classic example of a literary MacGuffin. While the ring plays a central role in the story and influences the characters' actions, its true narrative value lies in the need for its destruction to prevent it from falling into the wrong hands.

Similarly, in *Harry Potter and the Philosopher's Stone* by J.K. Rowling, the Philosopher's Stone acts as the MacGuffin. Harry and his friends must prevent the stone from being seized by villains, but the plot's

real intrigue lies in the challenges and adventures the characters face throughout their journey.

In video games, MacGuffins often take the form of items that the player must find to progress through the story. These could include keys to unlock doors, magical artifacts that grant special abilities, or characters who need to be rescued. In adventure games, the MacGuffin becomes a driving force in the plot, with the pursuit and recovery of the object often serving as the game's central objective.

For instance, in *The Legend of Zelda* series, the Triforce is the primary MacGuffin. This magical artifact grants immense power, and the protagonist, Link, must recover it to save the world from darkness.

In *Uncharted 2: Among Thieves*, the MacGuffin is Genghis Khan's Belt. The main character, Nathan Drake, races against the villain, Zoran Lazarevic, to find it first. In the *Final Fantasy* role-playing game series, the crystals serve as central MacGuffins. These crystals grant magical powers, and the protagonists must gather them all to save the world from destruction.

Why do film directors use the MacGuffin in their stories?

The answer is simple: the MacGuffin is an effective tool for maintaining tension and keeping the audience engaged. Even though it has no real importance to the story, its mere existence creates intrigue and curiosity, drawing viewers in. For example, in *Pulp Fiction*, the glowing briefcase's contents are never revealed, but its presence generates immediate curiosity. What's inside? Why is it so important?

A MacGuffin doesn't need to have intrinsic value or real relevance to the plot. What matters is that the characters are chasing it, and the audience becomes invested in whether or not they will succeed. In this way, the MacGuffin serves as an excuse for characters to act, fight, and make decisions, helping to move the story forward. Directors can use the

MacGuffin to introduce exciting elements, such as chases, conflicts, and unexpected plot twists. Often, it acts as the driving force behind the characters' actions.

George Lucas offers a slightly different interpretation of the MacGuffin compared to Hitchcock's. According to Lucas, the audience should care about the MacGuffin as much as they care about the characters. Using this perspective, the One Ring in *The Lord of the Rings* or Rosebud in *Citizen Kane* could be considered MacGuffins, as they carry emotional and thematic significance within their stories.

When analyzing films that employ MacGuffins, it becomes clear that each example is unique. Some adhere closely to Hitchcock's definition, treating the MacGuffin as a mere plot catalyst, while others imbue the object or person with emotional or thematic weight.

Using Multiple MacGuffins

It is not only possible but also effective to use multiple MacGuffins in a single film to maintain interest and suspense. Although MacGuffins are intended to be temporary plot devices, they always add an extra layer of intrigue, which audiences appreciate.

For example, in *Pulp Fiction*, two distinct MacGuffins stand out: the briefcase and the gold watch. Both objects are significant to the characters and are pursued relentlessly throughout the film. However, by the end, their relevance to the plot becomes secondary to the characters' development and personal journeys.

In *Indiana Jones and the Kingdom of the Crystal Skull*, there are several MacGuffins. The crystal skull is one, but there is also the key to the lost city, which the characters need to reach El Dorado. Each object drives

different parts of the narrative, but their real importance lies in the action, challenges, and adventures the characters experience along the way.

Types of MacGuffin

1. Clingy MacGuffin

> *How many times have you thrown a magic ring into the depths of the ocean, and when you come back and have a nice turbot for tea, there it is?*
>
> —Nanny Ogg, *Wyrd Sisters*

This is a MacGuffin that you don't chase because you already have it—but you can't get rid of it. It can't be removed, lost, given away, buried, thrown into the ocean, blown up, or separated from its owner in any way. Typically, it is neither intelligent nor sentient, yet it's bound to the character, for better or worse, until death—or some other extraordinary event—parts them. This type of MacGuffin often appears in fairy tales, especially in stories involving self-fulfilling prophecies. Characters will try desperately to get rid of the object triggering the curse, only for it to come back to them again and again.

If a Clingy MacGuffin appears in a series, several episodes might explore the character's attempts to escape it and live a normal life. The character might even succeed briefly, but circumstances will always force a reunion—because, after all, without the MacGuffin, there is no story.

In *Click*, the Universal Remote Control serves as an example of this device. Once the protagonist realizes the harmful effects it has on his life, he repeatedly tries to discard it, only for it to reappear in unexpected places. He throws it in the trash, tosses it farther outside, yet it keeps showing up—in his pocket, his pants, or even on his head when he takes off his clothes.

The One Ring from *The Lord of the Rings* is another example of a Clingy MacGuffin. In the book, it's explained that even if thrown into the sea, the Ring would eventually resurface by compelling a fish to swallow it. If buried beneath a mountain, it would torment the mind of anyone who knew its location. The film adaptation communicates this concept succinctly: the Ring can only be destroyed in Mount Doom. It cannot be guarded, buried, or lost forever—it always calls out to the nearest person to possess it and cannot be resisted for long. Ultimately, the Ring's goal is to return to its creator.

2. Fakin' MacGuffin

> *Ugh! I see. He's taken a barnacle and covered it with bioluminescent algae... as a distraction!*
>
> Tamatoa, *Moana*

When an important plot device is needed, one effective trick is to create a replica of the object to deceive the opponent into believing the fake is the real MacGuffin. The effect of the decoy can vary: sometimes it destroys the villain when they attempt to use it, or it may accidentally grant the hero the item they were trying to steal. Other times, the fake simply does nothing at all. Ideally, the existence of the decoy MacGuffin should be established beforehand, with some effort made to explain why the villain doesn't immediately realize it's counterfeit.

If the MacGuffin is stored in a distinctive container—one that holds significance only because it contains the object—this narrative device is likely to be used, as even an empty container can serve as an effective decoy.

In *Indiana Jones and the Last Crusade*, the real Holy Grail is hidden among a collection of fake ones. Elsa hands Donovan one of the false Grails, resulting in his death, as drinking from a counterfeit Grail proves to be lethal.

In the first *Mission: Impossible* film, the protagonist hands over one of two disks. He then convinces his adversary that the disk he gave them is a fake, causing the villain to discard it. After the rival leaves the room, the protagonist retrieves the disk from the trash, revealing it to be the real one all along.

In *Ronin*, the characters attempt to steal a silver briefcase. During their first try, they discover that the briefcase is a decoy with a bomb inside, swapped by one of their own team members. Their leader narrowly avoids disaster, realizing the switch just in time when he notices fresh silver paint left on his hand.

3. Dismantled MacGuffin

> *Professor: Obviously, I'll leave it here with t... Leave... It's logical, so the device... I'll leave it... Read... I'll leave it...*
>
> *Professor: NO!!! I'm sorry, but the impulse is too strong! I will split the punch card into seven pieces and hide them deep within seven monster-infested dungeons scattered across the country!!! Tell that to any group of people who come asking for it...*
>
> The B-Movie Comic

A common narrative device involves characters splitting a powerful ancient artifact—previously used to defeat a villain—into parts

and scattering them across the world, believing it to be "too dangerous to use again." When the villain resurfaces years later, the heroes must embark on a quest to reassemble the artifact. Typically, an important object is divided into pieces and hidden in different locations. Anyone who wants to possess the object must recover and recombine all the parts.

In *Star Wars: Episode VII – The Force Awakens*, both the Resistance and the reorganized Galactic Empire search for a map leading to the now-reclusive Luke Skywalker. Resistance pilot Poe Dameron recovers part of the map, but it turns out to be incomplete, missing a star system. By the film's end, the missing section is found within the dormant R2-D2. This artifact-fragmentation trope often includes a twist: the object may have been dismantled because it possesses a dangerous will of its own or to prevent it from falling into the wrong hands.

In *The Phantom* (1943), the Lost City of Zoloz was abandoned, and its people divided a map into seven parts, each group taking a piece to keep the city hidden until they reunited. However, as one character points out, the plan didn't go as intended. Over the centuries, many map fragments ended up in strangers' hands, and by the time the story begins, Professor Davidson has managed to collect all but one. If the reassembled artifact possesses enhanced abilities, it benefits from a "set bonus": the whole becomes greater than the sum of its parts.

In the *Marvel Cinematic Universe*, the six Infinity Stones are individually powerful, but when placed in the Infinity Gauntlet, they give the wielder the ability to wipe out half of all life in the universe with a single snap. In *Avengers: Infinity War*, Thanos uses this power, and in *Avengers: Endgame*, it is revealed that he destroyed the Gauntlet to prevent anyone from undoing his actions. The Avengers are then forced to travel through time to retrieve past versions of the Stones, forge a new Gauntlet, and reverse the Snap.

The fragmentation of artifacts can also create parallel plotlines, especially when different characters hold pieces during the search.

However, despite being fragmented, the object may not always be a MacGuffin. If the assembled artifact serves a functional purpose within the story—such as the Infinity Gauntlet—it is not a MacGuffin. On the other hand, if the story revolves solely around retrieving and assembling the parts but never using the artifact's power, it functions more like a MacGuffin.

4. Memento MacGuffin

This trope refers to an object that embodies or symbolizes the strong emotional bond between two characters or represents an important memory or period in someone's life. It can be something as simple as an engagement ring, a wedding video, a photograph of a loved one, or a treasured heirloom. It might also be a love note or a small gift, like a stuffed animal. For example, the Aztec gold talisman in *Pirates of the Caribbean: The Curse of the Black Pearl* serves as a trinket belonging to orphaned Will Turner, which Elizabeth takes from him when they first meet.

A Memory MacGuffin can even be a place, such as a childhood home, a favorite corner market, an old building filled with cherished memories, or an entire city. These objects or places symbolize more than just material value; they represent romantic relationships, deep friendships, family ties, or even more abstract connections.

What makes these objects unique is the symbolic and emotional synchronicity they share with the relationships they represent. For example, in *Inception*, Cobb's spinning top serves as his totem, grounding him in reality, but it originally belonged to his late wife, Mal. The top becomes a symbol of both his love for her and the emotional burden he carries.

While these elements receive significant narrative attention, they don't always act as true MacGuffins. Instead, they often play a crucial role

in the plot, driving emotional beats or decisions. However, Memory MacGuffins tend to come with emotional stakes: if a character deliberately discards the object, it indicates that it no longer holds meaning for them, signifying emotional closure or detachment from the past.

This brings us back to *Citizen Kane* and the iconic "Rosebud." Throughout the film, people assume "Rosebud" refers to a lost love or important person from Kane's past. In the end, however, we learn that it was the name of a childhood sled, symbolizing Kane's lost innocence and a simpler time in his life.

A specific variation of the Memory MacGuffin emerges in narratives centered around orphans or characters with absent or unknown parents. In these cases, the "treasure" the character carries often represents a connection to a lost family or origin, giving it even more emotional weight.

An example of this is the gold watch in *Pulp Fiction*. While many assume the watch symbolizes Butch's respect for his father, grandfather, and great-grandfather, the story hints at something more profound. One could argue that the most important figure in the watch's journey is Winocki, the door gunner who receives the watch from Butch's grandfather and promises to deliver it to Butch's father. Winocki had no personal connection to Butch's family—he had never met the grandfather—yet he kept his promise. This suggests that the watch may not symbolize family loyalty or honor, but rather the importance of keeping a promise, no matter the personal cost or consequences.

5. Fatal MacGuffin

Sometimes, the MacGuffin everyone has been chasing turns out to be much more (or much less) than it seems, and obtaining it might bring consequences far worse than expected. In some cases, it's actually better to

lose the race to possess it, especially when doing so could lead to fatal consequences. The *Indiana Jones* series is full of such examples. This trope can unfold in a variety of ways. Sometimes, the hero is on the verge of obtaining the object, only for the villain to seize it—and pay the price for their greed.

For example, in *Indiana Jones and the Temple of Doom*, the Sankara Stones aren't inherently lethal to most people. However, Mola Ram discovers their sacred touch burns him, and this ultimately causes his downfall. As he tries to grab one while hanging off a cliff, the stone's burning power forces him to lose his grip, sending him to his doom. Meanwhile, Indiana Jones chooses to return the stone to the village it originally belonged to, rather than keeping it for "fortune and glory," as he initially planned.

In other cases, there may be a cryptic warning about the price of claiming the MacGuffin. The hero may have to decipher the warning just before the villain takes possession of the object. A pragmatic hero might stay silent, allowing the villain to seal their own fate. A nobler hero, however, might try to warn the villain, only to be ignored—leading the villain to take the object anyway, often to their doom.

Indiana Jones and the Last Crusade provides another iconic example. The Holy Grail grants eternal life and healing, but as a test of character, it's hidden among many cups in a room where those seeking the Grail must choose the correct one to drink from. Picking the wrong cup causes the drinker to rapidly age thousands of years in mere seconds, turning them to dust. Additionally, attempting to remove the true Grail from its resting place triggers an earthquake that makes escape impossible. Elsa, blinded by greed, falls to her death as she refuses to give up trying to retrieve the Grail. Indy nearly meets the same fate but is saved when his father—who has spent his life chasing the Grail—finally tells him to let it go.

Phlebotinum

Don't touch the phlebotinum in the corner.

—David Greenwalt

(screenwriter of *Buffy the Vampire Slayer*)

You may not have heard of this term before, as it isn't as well-known as *MacGuffin* or *cliffhanger*, but you've likely encountered it in many series and films. A *phlebotinum* is a magical or technological element that allows the plot to progress. For example, it could be a magical object that grants powers, a secret formula that extends a character's life, or a machine capable of altering reality. This narrative device is especially common in television, but it also appears in books and films, particularly within the fantasy and science fiction genres.

The origin of the term isn't rooted in Latin or Greek, but is far more spontaneous. According to Joss Whedon, in the DVD commentary for the first episode of *Buffy the Vampire Slayer*, the term *phlebotinum* arose from an offhand remark by David Greenwalt, a writer and director on *Buffy* and co-creator of *Angel*. During a writers' meeting, as they struggled to advance the plot, Greenwalt jokingly said, "Don't touch the phlebotinum in the corner." And thus, the term was born.

The *Buffy* series is famous for employing such devices, using a variety of mystical objects and events to drive its narrative arcs. Phlebotinums are versatile tools, appearing across genres: in science fiction, where advanced technology moves the plot; in superhero films, where characters' powers take center stage; and in fantasy stories, where magic plays a crucial role. They're also prevalent in TV shows where special abilities or items help protagonists overcome challenges and push the story forward.

Much like a *MacGuffin*, a *phlebotinum* is a narrative tool that doesn't require detailed explanation. Writers hope audiences will accept it without much scrutiny. It might be grounded in science—like nanotechnology or a sonic screwdriver—or entirely fantastical, like healing crystals or fairy dust. The key is that the *phlebotinum* ensures the story continues. Without it, the narrative would come to a halt.

Phlebotinums for Plot Development

Phlebotinums are valuable tools for advancing a story because they offer creative ways to move the plot forward. These magical or technological elements provide characters with the means to solve problems and overcome challenges.

For example, episodes of *CSI: Crime Scene Investigation* and its spin-offs frequently rely on phlebotinums. One of their favorites is luminol, a substance used to reveal traces of blood. Although luminol exists in real life, it is neither as effective nor as widely used as depicted in fiction. By using such elements to solve crimes, the show's phlebotinum gains a veneer of scientific respectability.

Phlebotinums can also introduce new ideas and themes, keeping the audience engaged. In *Everything Everywhere All at Once*, for instance, the characters wear earbuds that allow them to jump between universes.

We don't need to know exactly what they are or how they work—their purpose is to enable the epic moments and adventures that drive the story. Without these devices, the narrative wouldn't unfold in the same way.

Phlebotinums for Character Development

Beyond driving the plot, phlebotinums also serve as tools for building characters and revealing their traits. Take kryptonite, for example. It was introduced into Superman's story to expose his vulnerability. As the "Man of Steel," Superman needed an Achilles' heel—a strange rock that could render him mortal.

Phlebotinums also allow characters to showcase their skills and personalities, helping audiences connect more deeply with them. Sometimes, a character gains new abilities through a phlebotinum, allowing them to overcome unexpected obstacles. This offers the opportunity to demonstrate charisma and resilience while working toward their goals.

A great example is Evelyn from *Everything Everywhere All at Once*. Without the earbud that lets her traverse the multiverse, she wouldn't have acquired the skills she develops by experiencing alternate lives.

Best Genres for Phlebotinums

Phlebotinums fit well across various genres, from fantasy to drama, due to their versatility. Whether magical or technological, they enable writers to explore new ideas and push the boundaries of genres like science fiction.

In fantasy, a character might wield a magic wand to summon a spirit or open a portal to another world. In science fiction, a time machine could allow travel to the past or future. A classic example is the DeLorean from *Back to the Future*.

Phlebotinums also create exciting situations for characters. For example, a protagonist might search for a magical stone containing divine power, sparking a compelling quest that requires wit and skill—much like Indiana Jones's pursuit of the Ark of the Covenant.

The nature of a phlebotinum depends on the story being told. In fantasy, it could be a spell or potion; in science fiction, it might be advanced technology, such as a robot or time machine. In adventure stories, it could take the form of a key, ancestral relic, or enchanted sword. Regardless of its form, the phlebotinum must help the protagonist solve a problem and guide them toward their goal. It could be an object the hero finds or a skill they develop during their journey. In every case, the phlebotinum serves as both a driving force and a tool for completing the mission. Without the DeLorean, Marty couldn't travel through time; without the earbud, Evelyn couldn't explore the multiverse.

The Use of Phlebotinum in a Story

The key to using a phlebotinum effectively lies in integrating it organically into the plot without forcing its presence. Rather than introducing a phlebotinum as just another element, it can be woven into the story through character interactions or dialogue.

Phlebotinums can also create crises. In this scenario, the phlebotinum becomes a central element that sparks a problem the protagonist must resolve. For example, the DeLorean in *Back to the Future* malfunctions, placing Marty in a race against time to repair it. This kind of

time-sensitive situation heightens narrative tension and creates opportunities for dynamic character development.

Additionally, a phlebotinum can open the door to alternate timelines or dimensions, allowing characters to explore different realities. This adds narrative depth and provides character growth as they learn from experiences in the past, future, or other universes.

Phlebotinums are also effective for building suspense. In *Raiders of the Lost Ark*, Indiana Jones's primary objective is to find the Ark of the Covenant before the Nazis do, keeping viewers engaged until the end. At the same time, the mystery surrounding the phlebotinum fuels curiosity—audiences want to know what the Ark is and how it works.

A good phlebotinum should operate under clear rules to prevent it from becoming a narrative crutch. These rules help the audience understand how the element fits into the story and ensure it isn't overused. By setting limitations, writers encourage creative problem-solving and allow the plot and characters to evolve naturally.

For example, in *Everything Everywhere All at Once*, Evelyn's earbud doesn't activate with a simple button press—she must perform absurd actions for it to work. These quirky rules not only create moments of comedy but also add unpredictability, complementing the chaotic storytelling style of the Daniels.

Fish Out of Water

The fish doesn't know it's in water until it's taken out.

Adam Smith

In colloquial language, the expression "like a fish in water" refers to someone feeling very comfortable in an environment that matches their personality or behavior. In narrative terms, however, the expression "a fish out of water" conveys the opposite: it refers to a character—usually the protagonist—finding themselves in an environment where they feel uncomfortable because it is completely unfamiliar. This stark contrast creates the story's main conflict.

For this concept to work, the character must not only be placed in a new setting but also in one that is entirely strange, making them feel deeply out of place. Just as a fish taken out of water struggles to breathe, the protagonist must be placed in an environment where they don't belong—and the more mismatched the setting, the better. From there, the story intensifies by forcing situations that make the protagonist's experience as challenging as possible. Exaggeration and pushing the premise to its limits are key to this narrative device.

A Fish Out of Water in Different Media

The fish-out-of-water concept can be explored not only in films or series but also through the creation of television programs.

Reality Show

The television format that has made the most use of the fish-out-of-water concept is the follow-along reality show or docushow. These

programs place an anonymous person or celebrity in a reality completely different from their own, where they must live under new conditions on camera and learn from the experience.

The first format of this kind to air was *The Simple Life*, a reality show in which Paris Hilton and Nicole Richie give up their cell phones, credit cards, and celebrity status to move in with a farming family in Arkansas for a month. The contrast is guaranteed, and with it, the conflict.

In *The Secret Millionaire*, a wealthy person is placed "at a poor man's table." An entrepreneur goes undercover to live with a poor family, experiencing firsthand the challenges disadvantaged groups face. At the end, the millionaire reveals their identity and offers financial help or employment, symbolically bringing the poor into their own circle.

In *Famous, Rich and Homeless*, a group of celebrities spends ten days living as homeless people. They are abandoned on the streets without money or belongings, left to fend for themselves during the ten-day shoot, with ten nights of hardship.

This concept is pushed further in *Perdidos en la Tribu* (Lost in the Tribe). "Three families, three primitive tribes, and three unknown destinations will become the adventure of a lifetime." In this show, three Spanish families leave their Western lifestyles behind to live with some of the oldest tribes in the world. They must adapt to their hosts' primitive ways, navigate a wild environment, and coexist with strangers for an extended period.

This journey doesn't always have to be geographical—it can also be a trip back in time, as shown in the program *Curso del 63*. This show is an adaptation of the British reality series *That'll Teach 'Em*, in which 20 young participants live in a boarding school recreated as if it were 1963. The only modern technology allowed are the participants' microphones, the cameras, and the confessional, where they can express their feelings or request psychological help when needed.

Science Fiction

Although the fish-out-of-water concept can be used in any genre, it is particularly prevalent in science fiction, especially in time-travel stories. A character who travels to the past or future finds themselves in a completely unfamiliar context and must learn to adapt. The resulting contrast ensures plenty of conflict.

In the classic *Back to the Future*, the protagonist is transported to the 1950s, an era governed by different rules and technologies. He must navigate this new reality, with the advantage of knowing what will happen in the future. However, the situation becomes more challenging when characters travel from the past to the present.

In the French film *Les Visiteurs*, quirky characters from the Middle Ages are magically transported to the late 20th century. Disoriented in a world that feels utterly foreign and hostile, they do everything in their power to return to their own time. Meanwhile, their medieval customs and habits confuse and unsettle the modern people they encounter.

Many alien-centered films also employ this narrative device. This is the foundation of *E.T. the Extra-Terrestrial*, where an alien must adapt to life on Earth. The device works particularly well in comedy, as demonstrated in series like *Mork & Mindy*, *My Favorite Martian*, or *ALF*, and in the film *My Stepmother Is an Alien*.

Comedy

In fish-out-of-water comedies, there are typically two contrasting scenarios:

- **A normal character in a comedic world**
- **A comedic character in a normal world**

A Normal Character in a Comedic World

Time-travel comedies often place an ordinary character in a bizarre or humorous setting. The comedic tension arises from the character's struggle to explore this new world and how it contrasts with the one they came from, whether it's the past or the future.

A prime example is *Sleeper* by Woody Allen, where a man is accidentally frozen and wakes up 200 years in the future, only to find himself in a surreal and comedic society.

A Comedic Character in a Normal World

Many comedies about aliens fit into this category. Series like *ALF* or films like *E.T. the Extra-Terrestrial* derive their humor from the clash between the quirky perspective of the alien character and the conventional human reality in which they now find themselves. The comedic essence lies in the alien's struggle to understand human norms and how humans react to their peculiar behavior.

How to Create a Fish Out of Water Story

Let's explore some options for crafting a story where the protagonist finds themselves out of their element.

1. Send Your Protagonist to the Past

The first option involves altering the timeline by sending the character to the past. Here, the 'traveler' might interact with people connected to them or their ancestors, as in *Back to the Future*, or encounter events that influence their present. The challenge of navigating a world with less advanced technology will inevitably create plenty of conflict—or humor.

2. Send Your Protagonist to the Future

In this scenario, the main character travels to the future. If the protagonist originates from the present, the story will speculate on what lies ahead. Alternatively, if the character comes from the past and arrives in the present, as in *Les Visiteurs*, the dynamic shifts. The protagonist struggles with today's modern technology and resources, generating humor or tension from the clash between old and new worlds.

3. Drastically Transform Your Protagonist, Making Them a Fish Out of Water in Their Own World

A significant change can make the character feel out of place, even within their familiar environment. This transformation can be external, like in *Big*, where Tom Hanks' character suddenly turns from a child into an adult overnight.

Alternatively, the transformation can be internal, as in *What Women Want*. In this comedy, a self-centered and sexist ad executive is electrocuted by a hairdryer in his bathtub. After miraculously surviving, he gains the ability to hear the thoughts of the women around him. The fish-out-of-water dynamic lies in placing a man inside the mental world of women, where he struggles to adapt to this new perspective.

Sometimes, the transformation is only superficial. In *Tootsie*, an actor disguises himself as a woman to secure a role, completely upending his reality. Similarly, in *Some Like It Hot*, two musicians dress as women to escape from gangsters and join an all-female band.

4. Drastically Change Your Protagonist's Context by Sending Them to a Strange Environment

This category includes survival stories that follow the Robinson Crusoe archetype. In films like *Cast Away* or *The Martian*, the protagonist is placed in an unfamiliar and hostile setting where they must fight to survive. However, a fish-out-of-water story doesn't always involve a wild, uncivilized environment.

Sometimes, the story takes the opposite approach, with a character from an untamed setting entering modern civilization. This is seen in *Tarzan's New York Adventure* and the reality series *Perdidos en la Tribu*. In the latter, tribal members are transported to modern-day cities in a version called *Perdidos en la Ciudad*, where they must adapt to a completely new way of life.

This category also includes narratives where characters—voluntarily or involuntarily—travel to strange worlds to achieve a goal. In *The Little Mermaid* and *Splash*, mermaids depart their submerged dwellings to pursue romance with human partners, initiating adventures characterized by conflict and discovery.

Rabbit hole

> *I clearly remember... that I began by sending my heroine down a rabbit hole without the slightest idea of what would happen next.*
> — Lewis Carroll's Diary

A *rabbit hole* is a plot trigger that opens a new and magical world for the protagonist. This narrative device represents a break from the character's mundane life in their ordinary world. The protagonist ventures into an unknown and often dangerous realm, where they experience fantastic adventures before eventually escaping and returning home safely.

Origin of the Rabbit Hole Device

The term "rabbit hole" originates from *Alice's Adventures in Wonderland* by Lewis Carroll, better known as *Alice in Wonderland*.

Chapter 1: Down the Rabbit-Hole

"*Alice was beginning to get very tired of sitting by her sister on the riverbank and of having nothing to do; once or twice, she*

had peeped into the book her sister was reading, but it had no pictures or conversations. 'And what is the use of a book,' thought Alice, 'without pictures or conversations?'

So she was considering in her own mind (as well as she could, for the hot day made her feel very sleepy and stupid) whether the pleasure of making a daisy chain would be worth the trouble of getting up and picking the daisies, when suddenly a White Rabbit with pink eyes ran close by her.

There was nothing very remarkable in that, nor did Alice think it so very much out of the way to hear the Rabbit say to itself, 'Oh dear! Oh dear! I shall be too late!' (When she thought it over afterwards, it occurred to her that she ought to have wondered at this, but at the time it all seemed quite natural). But when the Rabbit actually took a watch out of its waistcoat pocket and looked at it, and then hurried on, Alice started to her feet, for it flashed across her mind that she had never before seen a rabbit with either a waistcoat pocket or a watch to take out of it. Burning with curiosity, she ran across the field after it and was fortunate enough to slip down a rabbit-hole under the hedge just in time to see it disappear. In another moment down went Alice after it, without a thought of how she was ever to get out again."

In this passage, Alice plunges into a well, entering a marvelous world populated by strange characters. This well is the gateway to Wonderland. Throughout the book, Alice encounters surreal situations that defy logic and even imagination. She nearly drowns in a pool of her own tears, participates in a circular caucus race, plays croquet using a flamingo as a mallet and live hedgehogs as balls, and attends a nonsensical trial. Wonderland operates outside the rules of reality, creating a chaotic realm where anything is possible.

Other Stories with Magical Rabbit Holes

The rabbit hole concept appears in many forms across various storytelling mediums to transport characters to fantastical worlds. In addition to *Alice's Adventures in Wonderland*, many beloved stories use this narrative device. Books such as *Charlie and the Chocolate Factory*, *Coraline*, *The Chronicles of Narnia*, *The Wizard of Oz*, and *The NeverEnding Story* feature protagonists crossing a threshold into extraordinary realms.

This trope is also prevalent in films, including *Labyrinth*, *The Matrix*, *Being John Malkovich*, *Pan's Labyrinth*, and *TRON*.

The narrative concept even extends to tabletop role-playing games like *Heroine*. Unlike most RPGs, *Heroine* has no combat mechanics and focuses instead on recreating narrative experiences inspired by stories like *Labyrinth*, *The Wizard of Oz*, *Alice in Wonderland*, or *The Chronicles of Narnia*. One player takes on the role of the heroine—a brave girl trapped in a magical world—while the other players embody her eccentric companions. Together, they seek a way for her to return home while overcoming obstacles and villains controlled by the game's Narrator.

Alternate Reality Games (ARGs) also incorporate the rabbit hole concept as a gateway between the real world and a fictional, immersive experience. Some ARGs unfold entirely in digital spaces—using websites, multimedia, and emails—while others require participants to engage with physical locations or objects.

In ARGs, thousands of players may collaborate to solve puzzles and unravel a plot, or a small group might become the protagonists of a personalized story. Regardless of scope, every ARG begins with the blending of fiction and reality. This entry point into the game, known as a

rabbit hole, can be subtle or obvious, and it may be open to all participants or restricted to a select few.

How to Use the Rabbit Hole Device

To effectively incorporate the rabbit hole element into a story, it's important to carefully consider the magical world that the protagonist will enter, the doorway that grants access to it, and the structure of both the journey and return.

1. The Doorway to the Magical World

The concept of a portal leading to a magical realm has evolved through various adaptations of *Alice's Adventures in Wonderland*, where Alice falls down a literal rabbit hole, often represented as a dark tunnel.

This motif frequently appears in Studio Ghibli films. In *My Neighbor Totoro*, Mei first encounters Totoro after following a small, white, rabbit-like creature through a tunnel. In *Spirited Away*, the protagonist passes through a long, dark tunnel into the spirit world.

In *Coraline*, the protagonist crosses a mysterious door in her living room, leading to an alternate version of her home, inhabited by seemingly perfect versions of the people she knows.

The portal may also lead into a labyrinth that complicates the character's journey. In *Labyrinth*, Sarah becomes trapped in a maze-like dungeon that is only one part of the vast labyrinth. Similarly, in *Pan's Labyrinth*, Ofelia encounters a series of trials—crawling through mud under a tree, meeting the Faun at the bottom of a well, and facing the Pale Man under a bedroom floor.

In *The Wizard of Oz*, Dorothy's portal is not a literal hole but a tornado that transports her to the land of Oz. The tornado functions metaphorically as a hollow structure, akin to a rabbit hole.

A creative variation of this device appears in *Being John Malkovich*. Here, the protagonist discovers a hidden hole behind a filing cabinet, leading directly into John Malkovich's mind. For 15 minutes, the character experiences life from Malkovich's perspective before being ejected onto a ditch along the New Jersey Turnpike. This film exemplifies that the entrance to a magical world does not always align with the exit, and the protagonist often discovers the way out only after learning a valuable lesson during their adventure.

2. The Magical World

Rabbit hole stories inherently involve fantastical realms that exist between two contrasting worlds: the ordinary reality the protagonist leaves behind and the magical domain where strange adventures unfold. These characters often crawl through tunnels, descend underground, or find themselves confined in tight spaces.

While the doorway may appear in the real world, it serves as a portal to a fantastical realm often associated with dreamscapes or shamanic journeys, both ancient and modern. In *Trainspotting*, for example, Renton dives into the filthiest toilet in Edinburgh and swims underwater—a surreal sequence that plays out as a drug-induced hallucination.

These magical worlds are populated by bizarre, mysterious, or humorous characters. In *Alice in Wonderland*, Alice encounters peculiar beings, such as a hookah-smoking caterpillar, the grinning Cheshire Cat, and the Mad Hatter and March Hare locked in an endless tea party. She also meets playing-card gardeners painting roses and a tyrannical Queen obsessed with shouting, "Off with their heads!"

3. The Journey and the Return

The narrative structure of rabbit hole stories aligns with what Christopher Booker describes as *The Voyage and Return* in his book *The Seven Basic Plots: Why We Tell Stories*. Though often used in children's tales, this structure is also found in adult narratives such as *The Matrix* and *Being John Malkovich*.

In this plot, the protagonist leaves behind their familiar world and ventures into unknown, perilous territory. After experiencing trials and transformation, they escape and return home safely, enriched by personal growth. The magical world they explore operates under different rules than those of reality. Initially, the protagonist is fascinated by it, but they soon encounter its darker aspects. Through these challenges, they develop new skills and insights, ultimately finding a way back home.

Typically, the protagonist brings nothing tangible back from the magical realm—only the growth they have achieved through their experiences. In these stories, logic is often replaced by intuition, kindness, and the ability to form alliances.

According to Booker, this plot unfolds in five key stages:

1. Anticipation: The protagonist begins in a state of boredom, curiosity, or impulsiveness, often unaware of life's complexities due to youth or immaturity. They stumble upon an alternate reality and cross a magical threshold into a new world.

2. Dream or Fascination: The protagonist explores the strange world, finding it thrilling but never fully comfortable.

3. Frustration: The initially exciting world grows dark and threatening, as a looming shadow begins to manifest.

4. Nightmare: The shadow fully emerges, overwhelming the protagonist, who seems on the verge of defeat.

5. Escape and Return: Just as all hope appears lost, the protagonist manages to escape and return home, transformed by their experiences and now more mature than before.

Chandler's Law

When you don't know what to do, have a man come through the door with a gun in his hand.

Raymond Chandler

Chandler's Law originates from a quote attributed to Raymond Chandler, the renowned mystery novelist known for his iconic character Philip Marlowe, a private detective navigating the seedy underworld of Los Angeles. The law was referenced in a letter Chandler wrote to a fellow writer, offering insight into a strategy he used when his writing felt stuck. In Chandler's crime and mystery fiction, the sudden entrance of an armed man introduced an immediate physical threat, forcing characters to react and driving the plot forward.

The principle is summarized as: **"When in doubt, have a man come through the door with a gun."** In essence, if the narrative reaches a dead end or becomes overly tangled, the introduction of an unexpected element—usually action or danger—can disrupt the stagnation, change the course of the story, and recapture the audience's attention.

While this principle is a powerful tool for generating tension and excitement, it must be applied thoughtfully. Overuse or poorly integrated

plot twists can make the story feel contrived or predictable. Though action-driven moments can propel the plot, the coherence of the story and the believability of the characters' decisions within their narrative context are essential for maintaining narrative integrity.

Examples of Chandler's Law in Film and Literature

Chandler's Law has been adapted across various genres and storytelling formats over the years. While not all examples adhere to the literal "man with a gun" scenario, they capture the essence of the law: introducing conflict or tension when the plot risks stalling.

- **Game of Thrones**: Both George R.R. Martin's book series *A Song of Ice and Fire* and its television adaptation employ moments aligned with Chandler's Law. Whenever political intrigue or dialogue-heavy sequences begin to drag, a sudden burst of violence or a shocking twist re-engages the audience and propels the narrative forward.
- **Harry Potter and the Order of the Phoenix**: J.K. Rowling applies a similar tactic in this installment of the *Harry Potter* series. During a seemingly quiet meeting of the Order of the Phoenix, the unexpected arrival of Death Eaters injects immediate danger, reigniting the story's tension and driving the plot toward an action-packed climax.
- **Pulp Fiction**: Quentin Tarantino frequently follows the spirit of Chandler's Law throughout *Pulp Fiction*. When conversations or character interactions threaten to slow the pace, sudden bursts of violence or dangerous events occur, reigniting suspense and momentum.
- **The Godfather Saga**: Mario Puzo and Francis Ford Coppola use Chandler's Law to excellent effect in *The Godfather* films. Whenever intricate negotiations or political intrigue become overly complex, the introduction of violence—whether through

ambushes, assassinations, or betrayals—sparks new storylines and revitalizes the plot.

How to Incorporate Chandler's Law into Your Screenplays

1. **Identify Dead Points**
 First, identify moments in your screenplay where the plot might be losing momentum. These are the places where you can introduce a new element to re-energize the story. It can be helpful to get feedback from others, as they may have a more objective perspective and spot issues you missed.

2. **Plan Your Surprises**
 Once you've identified these dead points, brainstorm surprises or conflicts to revitalize the plot. This could be anything from the introduction of a new character, a plot twist, a revealed secret, or an unexpected event. Ensure that the new element aligns with the narrative's tone and logic to avoid feeling forced or disconnected.

3. **Build Towards Your Surprise**
 Instead of introducing your twist abruptly, lay the groundwork by planting subtle clues. This will make the surprise feel organic and believable, creating a payoff that feels satisfying to the audience.

4. **Analyze the Impact of the Surprise**
 After introducing the twist or conflict, take time to assess how it affects the characters and the overall story. How does it change the dynamics between characters? How does it shift the narrative's

direction? Fully exploring the consequences of this new development will enrich your story.

5. **Review and Adjust**
 Finally, revise your screenplay to ensure that the new conflict or twist integrates smoothly into the plot. Make adjustments as needed to maintain flow and coherence, ensuring that the narrative remains engaging and logical.

Alternatives to Chandler's Law for Jump-Starting a Stagnant Plot

While Chandler's Law suggests introducing a new conflict or character to revive a stalled plot, there are other ways to push the story forward. Here are a few alternatives:

1. Character Development

Delving deeper into your characters' personalities, backgrounds, and motivations can open up new plot possibilities. Internal conflicts or hidden desires might emerge, propelling the story in a fresh direction.

2. Explore Subplots

If the main plot reaches a dead end, exploring a subplot can provide a breather and add layers to your narrative. Subplots often lead to unexpected developments that can unlock new paths for the main story.

3. Flashbacks or Flashforwards

A flashback can introduce new information about a character or event, altering the audience's understanding of current situations and sparking new plotlines. Similarly, a flashforward can build suspense by hinting at future events, creating anticipation.

4. Revelations

Unveiling a secret, a betrayal, or hidden information can drastically shift character dynamics, injecting energy into the narrative and propelling the story forward.

5. Changes in Relationships

Transformations in the relationships between characters—such as reconciliations, breakups, or new alliances—can offer fresh momentum. These shifts often open new emotional and narrative avenues.

6. Setting Changes

Sometimes, relocating the characters to a new environment can revitalize the plot. A change in setting introduces new challenges and opportunities, forcing characters to adapt and evolve in unexpected ways.

Foreshadowing

> *The Dark Lord will rise again with the help of his servant, greater and more terrible than ever. Tonight... before midnight... the servant... will set out... to join... his master...*
>
> *Harry Potter and the Prisoner of Azkaban*

Foreshadowing is a narrative technique used in literature, film, and television. It involves **introducing elements into a story that hint at or suggest events that will unfold later**. These elements can appear in the form of dialogues, descriptions, images, symbols, or situations that might initially seem incidental but gain deeper significance as the plot develops.

The primary goal of foreshadowing is to **create anticipation and heighten dramatic tension**, preparing the audience or reader for future plot twists. When executed effectively, foreshadowing enriches the narrative experience by adding layers of meaning and depth, resulting in a stronger emotional impact when the hinted events finally occur.

For instance, in a mystery film, a seemingly trivial object introduced early on may later serve as a key clue to solving the case.

Similarly, what appears to be casual dialogue in a novel might contain subtle hints about a character's fate.

Foreshadowing can range from direct to subtle, often requiring careful attention to spot. Seasoned viewers and readers enjoy identifying and analyzing these narrative cues, which enhances their engagement with the story.

Examples of Foreshadowing in Film and Literature

- **The Lion King:** Scar's song *"Be Prepared"* offers multiple references to his plan to kill Mufasa and seize the throne, setting the tone for his future actions.
- **Titanic:** The description of the ship as "unsinkable" early in the film is a tragic foreshadowing of its eventual fate.
- **Romeo and Juliet:** Shakespeare hints at the tragedy when Romeo expresses a sense of foreboding before attending the party where he meets Juliet, foreshadowing the play's tragic ending.
- **Game of Thrones:** George R.R. Martin frequently employs foreshadowing. For example, Daenerys' visions in the House of the Undying provide glimpses of events that will occur later in the series.
- **Breaking Bad:** Creator Vince Gilligan masterfully uses foreshadowing. A notable instance is the pink teddy bear floating in Walter White's pool, which symbolizes an impending disaster.

How to Incorporate Foreshadowing into a Script

1. Subtle Integration

Introduce foreshadowing naturally through dialogue or setting details. Avoid drawing too much attention to it, so the audience only realizes its significance when the event unfolds.

Example: In *Fight Club*, Tyler Durden briefly appears in the background of several scenes before being formally introduced, subtly hinting at the character's dual identity.

2. Distract the Audience

Use foreshadowing in combination with distractions, so viewers focus on other aspects of the scene, making it harder to notice the clues.

Example: In *Game of Thrones*, with its numerous characters and subplots, foreshadowing elements like Bran's dreams can easily go unnoticed amidst the drama and intrigue.

3. Multiple Meanings

Present foreshadowing with more than one possible interpretation, keeping the audience uncertain until the event is revealed.

Example: In *The Lord of the Rings*, Galadriel's visions suggest potential futures, leaving their precise meaning open to interpretation.

4. Visual Foreshadowing

Employ visual elements to hint at future events. Sometimes, imagery can serve as a more powerful foreshadowing tool than words.

Example: In *American Beauty*, the recurring rose petals foreshadow the protagonist's obsession and eventual downfall.

5. Character-Driven Foreshadowing

Tie foreshadowing to a character's development or backstory, making it feel like a natural part of their journey rather than a narrative contrivance.

Example: In *The Godfather*, Michael Corleone's early involvement in family matters hints at his eventual rise to power.

6. Normalization

Incorporate foreshadowing into the characters' routines or their world, allowing it to blend seamlessly into the narrative until it becomes relevant.

Example: In *Harry Potter*, various magical elements at Hogwarts seem ordinary within the wizarding world but later prove essential to the story.

7. Symbolism and Metaphors

Use symbols or metaphors to convey foreshadowing, encouraging the audience to engage in deeper interpretation.

Example: In *Moby Dick*, the white whale symbolizes themes of obsession and revenge, acting as layered foreshadowing.

8. Time Gap

Allow a significant gap between the foreshadowing element and its resolution, making the connection less predictable for the audience.

Example: In *The Great Gatsby*, the billboard of Dr. T.J. Eckleburg's eyes represents morality and surveillance, but its full meaning is only understood toward the novel's conclusion.

9. Moderation in Use

Avoid overusing foreshadowing, as it can become predictable. Use it sparingly to maintain its impact and ensure it remains effective.

Example: In *Psycho*, Marion Crane changes into darker clothes after stealing money, subtly hinting at her dark fate. Hitchcock uses foreshadowing selectively, keeping it impactful and unexpected.

10. Double-Edged Foreshadowing

Present foreshadowing that appears to suggest one outcome but leads to an unexpected twist, keeping the audience engaged and surprised.

Example: In *The Hunger Games*, Katniss's mockingjay pin initially symbolizes her district, but it later evolves into an emblem of rebellion and change.

Breaking the Fourth Wall

> *¡Hey! Yes, you! I'm down here busting my ass while you sit on yours watching me jump. Is that fair?*
>
> Deadpool
>
> *(Marvel vs. Capcom 3)*

The fourth wall is the invisible, imaginary boundary at the front of a theater stage, television series, movie, comic, or video game through which the audience observes the characters. This wall is not only physical but also symbolic, marking the division between the story and the audience. It reminds viewers that they are outside the narrative, while the characters remain unaware of being watched.

The origin of the term "fourth wall" is theatrical. On stage, the three physical walls—left, right, and back—enclose the set. The fourth wall is figurative, representing the audience's perspective. When an actor directly addresses or interacts with the audience, they are said to "break the fourth wall."

In film, television, and video games, the screen serves as the fourth wall, maintaining the illusion that the characters are unaware of being

observed. When a character breaks this barrier—by looking into the camera, speaking to the audience, or making gestures—they acknowledge their fictional nature, momentarily stepping out of the narrative. For example, Groucho Marx often glanced at the camera mid-scene, as if silently acknowledging the audience's presence.

This rupture can occur in multiple ways:

- **Dialogue**: A character references their fictional nature.
- **Visual cues**: A character looks into the camera or gestures at the viewer.
- **Combined audio and visual elements**: A character both looks at the camera and addresses the audience directly.

Why Break the Fourth Wall?

Incorporating a character who breaks the fourth wall can be a stimulating exercise for screenwriters, as it surprises the audience and disrupts narrative continuity. However, this technique must be used purposefully; overuse or gratuitous breaks risk alienating viewers by reminding them they are watching a constructed narrative.

The impact of breaking the fourth wall depends on context and intent. Below are some of the most common reasons and effects for employing this technique:

1. To Generate Complicity

Breaking the fourth wall disrupts the fictional pact, briefly pulling viewers out of the narrative to remind them that the characters are

fictional. This can foster a sense of complicity between the audience and the character, as if they share an inside joke.

Example: Oliver Hardy frequently used this technique in the Laurel and Hardy films. After Stan Laurel made a blunder, Hardy would glance at the audience with a resigned expression, as if seeking their understanding.

Modern films and shows also use this device. In *The Lion King*, Timon warns Pumbaa to mind his language "because there are children watching." Similarly, in *Malcolm in the Middle*, the protagonist constantly addresses the audience. From the opening scene, Malcolm looks into the camera and says, "My name is Malcolm. Do you want to know the best part of my childhood?"

2. To Engage the Audience

Some characters break the fourth wall to prompt action or direct involvement from the audience. This approach is popular in children's media, where interaction enhances engagement.

Examples:

- *Peter Pan* invites the audience to clap to save Tinkerbell.
- In *Dora the Explorer*, characters ask questions and pause for viewers to respond.

Video games also exploit this technique. In the *Batman: Arkham* series, villains mock the player directly after a failed mission. In *Metal Gear Solid*, the villain Psycho Mantis scans the player's memory card and comments on saved Konami games, adding a meta twist.

3. To Generate Laughter

Comedy often thrives on breaking rules, including narrative conventions. Breaking the fourth wall can elicit laughter when characters step out of their roles to interact with the audience or make humorous observations.

Example: The antihero *Deadpool* constantly breaks the fourth wall, making jokes about being a fictional character. This irreverent humor extends to trailers and promotional material. In such comedies, the break itself becomes a gag, with characters acknowledging the absurdity of their circumstances.

4. To Create Unease

When used in psychological thrillers or horror, breaking the fourth wall can evoke discomfort. A character's direct gaze or interaction with the audience can be unsettling, turning complicity into unease.

Examples:

- In *Psycho*, Norman Bates stares directly at the audience, amplifying the creepiness of his character.
- In Michael Haneke's *Funny Games*, a character winks at the camera, implicating the viewer in the film's disturbing events.

5. To Provide Information

Breaking the fourth wall can serve an informational purpose, offering context or explaining complex ideas. This technique echoes the use of prologues in Shakespeare's plays, where actors addressed the audience to set the stage.

Examples:

- In *The Big Short*, the narrator breaks the fourth wall to explain complex financial concepts directly to the audience.
- In *House of Cards*, Frank Underwood addresses viewers to outline his political strategies, providing insight into his manipulative schemes.

6. To Reveal the Backstage

In some productions, breaking the fourth wall becomes a signature move, with characters openly acknowledging the fiction and even interacting with the crew. This meta-narrative approach exposes the mechanics of storytelling.

Examples:

- In *Moonlighting*, Bruce Willis's character frequently breaks the fourth wall, once quipping, "Tell that to the writers" in response to another character.
- In *Boston Legal*, characters toast to "next season" during the season two finale, openly referencing the show's production.

7. To Set the Tone or Genre

Breaking the fourth wall can establish a narrative's tone or genre. This is common in films that blend storytelling with monologues or meta-commentary.

Examples:

- In *Annie Hall*, Woody Allen addresses the audience in the opening scene, reflecting the film's roots in stand-up comedy.
- Parodies like *Scary Movie* and *Spaceballs* rely on breaking the fourth wall to mock genre conventions and engage viewers with playful satire.

Deus ex machina

I'll tell you a secret. The ending makes the movie. Win them over at the end, and you'll have a hit. You can have flaws, problems... but if you win them over at the end, you'll have a success. Find an ending... but don't cheat, and don't even think about using a Deus ex machina at the last moment. Your characters must change, but the change must come from within them. Do that... and you'll do well.

Robert McKee

(*Adaptation*)

Deus ex machina literally means "god from the machine." It refers to a pulley mechanism used in ancient Greek theater, where gods were lowered onto the stage to resolve seemingly unsolvable conflicts. Over time, the term has evolved to describe any narrative device in which an unexpected force or character intervenes to rescue protagonists from an otherwise hopeless situation. This intervention can come out of nowhere, from a hidden place, or from a source of power beyond human comprehension.

Deus ex machina has been a storytelling tool since Ancient Greece and continues to be employed to inject suspense, tension, and drama into modern narratives. However, it is often criticized for providing overly convenient resolutions that undermine the plot's development.

A classic example appears in *The Lord of the Rings*. After destroying the One Ring, Frodo and Sam find themselves stranded on the slopes of Mount Doom, on the brink of death from exhaustion and the mountain's overwhelming heat. With no provisions or means of escape, all seems lost—until giant eagles arrive, seemingly out of nowhere, to rescue them.

The Origins of Deus Ex Machina in Theater and Beyond

The concept originated in Greek tragedy, where supernatural entities, usually gods, would intervene to rescue characters from dire situations. This technique allowed playwrights to resolve complex plots swiftly. Over time, this narrative device spread across literature, television, film, and other formats.

Although it can be an effective storytelling tool, Deus ex machina is often criticized for being a simplistic solution that lacks organic plot development. Even Aristotle condemned its use in *Poetics*: "The resolution of a plot should arise from the plot itself, not rely on external intervention." Despite such criticism, some creators have employed the device effectively, infusing their stories with surprise and emotion.

Examples of Deus Ex Machina in Literature, Television, and Film

1. **Theater:**
 In *Medea* by Euripides, the Sun god sends a chariot to rescue Medea, allowing her to escape the consequences of her actions.

2. **Literature:**
 In *The Hobbit*, after the protagonists defeat the trolls, they discover—without prior explanation—that they possess the trolls' key, allowing them to access the lair. This is a clear example of a sudden resolution with minimal setup.
3. **Television:**
 Deus ex machina is common in episodic television. For example, *The Simpsons* often wraps up absurd storylines with convenient resolutions, ensuring everything returns to normal by the next episode. A memorable instance of this trope in Spanish television occurs in *Los Serrano*, where the entire series is revealed to be just a dream.
4. **Film:**
 In the 1978 *Superman*, the hero flies around the Earth in reverse to turn back time and save Lois Lane. The film offers no prior indication that Superman can manipulate time, making this a quintessential Deus ex machina moment.

The Pros and Cons of Deus Ex Machina

Advantages:

- It adds unexpected twists, keeping audiences engaged with sudden surprises.
- It can create dramatic tension by placing characters in seemingly unsolvable situations before offering a resolution.
- It accelerates plot progression, avoiding unnecessary complications.

Disadvantages:

- It can feel like a lazy narrative shortcut, leaving audiences disappointed.

- It undermines character agency, as protagonists are saved by external forces rather than their own actions.
- It risks making the story feel contrived and lacking in coherence.

How to Avoid Deus Ex Machina

To avoid relying on Deus ex machina, plot resolutions should emerge organically from the narrative. Authors can achieve this by:

1. **Establishing Consistent Rules:** Ensure that characters possess the necessary skills or knowledge to overcome challenges.
2. **Using Planting and Payoff:** Introduce subtle clues early in the story so that later developments feel earned. For example, if a seemingly miraculous solution appears, the audience should recognize its connection to earlier plot elements.
3. **Balancing External Help:** If external forces do intervene, ensure they come with complications, adding tension rather than neatly resolving everything.

How to Use Deus Ex Machina Effectively

Though risky, there are ways to employ Deus ex machina creatively:

1. **Use Humor:**

In *Life of Brian*, the protagonist falls from a tower, only to be saved by an alien spaceship. The film's absurd tone makes this unexpected rescue hilarious rather than frustrating.

This approach works best in comedies, such as *The Simpsons*, but would feel out of place in a serious drama like *Breaking Bad*.

2. Acknowledge the Implausibility:

In *Der Letzte Mann (The Last Laugh)*, the protagonist inherits a fortune in an improbable twist. An intertitle acknowledges the implausibility: "Here our story should end, but the author took pity on the old man." This self-awareness turns the Deus ex machina into a clever commentary.

3. Make the Deus Charming:

In *Die Hard with a Vengeance*, a construction worker unexpectedly knows the answer to a critical trivia question, providing the heroes with a solution. Though unlikely, the character's charm makes the twist more palatable.

Similarly, in *Toy Story 3*, the toys are saved from an incinerator by aliens using the mechanical claw, a moment made endearing by the characters involved.

4. Turn the Deus into a Problem:

In *Back to the Future*, a lightning strike provides the necessary power for time travel. The genius lies in presenting this event as a carefully planned but risky solution, rather than a random miracle.

5. Foreshadow the Deus Ex Machina:

In *Adaptation*, the crocodile's sudden intervention at the climax is ironic, as the film had already mocked the overuse of Deus ex machina throughout. This self-awareness makes the moment feel intentional.

Similarly, Gandalf's arrival at Helm's Deep in *The Lord of the Rings* is foreshadowed when he tells Aragorn, "Look to my coming at first light on the fifth day." This subtle setup transforms what could have been a contrived rescue into a satisfying payoff.

6. **Embrace Luck as a Theme:**

Films like *Magnolia* and *Match Point* openly explore the role of chance, preparing audiences for climaxes driven by luck. When chance intervenes, it feels thematically consistent rather than forced.

Diabolus ex machina

> *This is not the convenient plot twist that saves our heroes. This is the convenient plot twist that screws them over even more.*
>
> —Ryan MC, *Two Evil Scientists*

Diabolus ex machina is derived from *Deus ex machina*, functioning as its negative or inverse counterpart. This narrative device **introduces an unexpected, inexplicable, and unfortunate event that occurs without apparent reason, often driven by malice, tragedy, or to further complicate the plot.** While effective when used carefully and sparingly, it risks feeling artificial or manipulative if overused or poorly executed. Authors may employ sudden misfortunes without plot justification to provoke an emotional reaction or delay the story's resolution.

Examples of Diabolus ex Machina in Literature, Film, and Television

Literature and Theater

In *Romeo and Juliet* by William Shakespeare, a letter from Friar Laurence fails to reach Romeo, leading him to believe Juliet is dead. This twist—occurring due to a random series of unfortunate events—ultimately precipitates their tragic double suicide. The missed letter seems designed solely to push the story toward its heart-wrenching conclusion.

In *1984* by George Orwell, Winston and Julia's rebellion is abruptly crushed when O'Brien, whom they trusted, reveals himself to be a government agent. This betrayal feels engineered to amplify the story's bleak inevitability and underscores the hopelessness of resistance against the oppressive regime.

Film

In *A.I. Artificial Intelligence* by Steven Spielberg, David, a robot boy, spends two thousand years trapped underwater, longing to become human. When advanced beings finally rescue him, they can only recreate his mother for one day. This seemingly cruel twist heightens the emotional tragedy, leaving viewers with a sense of unresolved sorrow.

In *No Country for Old Men*, Llewelyn Moss, after surviving several deadly encounters with Anton Chigurh, is abruptly killed off-screen by a secondary character. His sudden death feels arbitrary, reinforcing the film's theme of random, senseless violence.

Television

In *Game of Thrones*, Daenerys Targaryen's decision to burn King's Landing was widely criticized as a Diabolus ex machina. While there were subtle hints about her instability, the sudden and disproportionate scale of destruction felt forced, shocking viewers more than serving the narrative.

The Walking Dead frequently employs unexpected deaths, with events that seem to emerge out of nowhere. For example, Beth's death in

season five happens just as she is about to be rescued, delivering a sudden and tragic twist that shocked fans.

In *A Nightmare on Elm Street*, the final scene delivers a last-minute twist: just as the characters believe they are safe, the car door locks, and Freddy Krueger launches a surprise attack. This ending serves as both a shock and a cliffhanger, setting the stage for future installments.

The identification of Diabolus ex machina can be subjective; what some may see as an arbitrary twist, others might interpret as an essential part of the narrative or reflective of the author's intent. In the films of the Coen brothers, for instance, sudden and harsh plot twists are an intentional stylistic choice, emphasizing the unpredictability of life.

Beneficial Uses of Diabolus ex Machina

1. **Subverting Expectations**:

 Diabolus ex machina can challenge audience expectations, delivering an unpredictable twist that leaves a lasting impression. This subversion can make the story more memorable and engaging.

2. **Establishing Tone**:

 In narratives that explore themes of **cruelty, absurdity, or fatality**, Diabolus ex machina can effectively reinforce the story's dark tone. It reminds the audience that life can be unpredictable and harsh.

3. **Generating Emotion**:

A sudden tragic event can be a powerful tool for creating **tension and emotional impact**. When used strategically, it can captivate the audience and keep them invested in the story. Additionally, this device can serve as a **cliffhanger** to set up a sequel, maintaining suspense across multiple installments.

4. **Character Development**:

 Diabolus ex machina offers opportunities to explore how characters react to trauma and adversity. These moments reveal **critical aspects of a character's personality**, providing insight into their resilience, fears, or vulnerabilities.

5. **Forcing Characters into Extreme Situations**:

 When introduced effectively, Diabolus ex machina can push characters into **seemingly insurmountable challenges**, forcing them to rely on ingenuity, courage, or resilience to overcome obstacles. These situations highlight the protagonist's inner strength and development.

Ticking clock

Whatever happened at 00:00:00 probably wouldn't be good.

—*Swellhead,* Kim Newman

The term "ticking clock" translates literally as "a clock that ticks," but in narrative terms, it refers to a device—also known as a countdown or race against time—designed to increase tension as a deadline approaches. This tool **imposes a time limit on the protagonist to solve a problem, heightening suspense and urgency.** The impending deadline accelerates the narrative, making the audience more invested in the outcome.

This storytelling mechanism has been used throughout history. Cinderella must leave the ball by midnight, or her carriage will turn back into a pumpkin. Similarly, Hansel and Gretel live with the implicit fear that the witch could eat them at any moment, adding tension even without an explicit countdown.

Objective: Generating Tension

The primary function of the ticking clock is to generate tension. It is often accompanied by sound effects—like a ticking timer—or, in the case of films like *Speed* or *The Dark Knight*, the threat of a bomb. However, bombs are not necessary to apply this technique.

Sometimes, all it takes is a **time limit** to force characters to act. When a problem can be solved "whenever," there's no urgency, and tension drops. Without tension, it becomes harder for the audience to care about what happens next.

How to Use a Countdown or Ticking Clock

A ticking clock serves as a time limit that introduces constraints, obstacles, and clear consequences. It typically operates under an "if-then" scenario: if the protagonist fails to act in time, a significant consequence will follow. To use this device effectively, you must establish the stakes and make the time limit clear to the audience.

1. The Setup

The ticking clock can structure the entire story or serve as a smaller element within individual scenes.

- **Throughout the story**: In *Run Lola Run*, Lola has 20 minutes to gather 100,000 German marks and save her boyfriend's life.
- **In a single scene**: In *The Dark Knight*, two ferries—each rigged with bombs—have limited time to make a critical decision.

You can introduce the time constraint at different moments:

- **At the beginning**: The countdown frames the central conflict from start to finish. In *Speed*, a bus will explode if it drops below 50 mph, forcing the characters to stay in motion.
- **In the final act**: Many action films use a countdown to heighten the climax. In *Back to the Future*, Doc must position the DeLorean perfectly to send Marty back to 1985 before lightning strikes.

- **In intermediate moments**: Some stories use multiple smaller countdowns to maintain tension. In *Titanic*, Rose must rescue Jack from the lower decks before the ship floods completely.

2. The Ticking Clock

A ticking clock is not always a literal timepiece—it can take many forms:

- In *Cinderella*, the clock represents the **midnight deadline** when her magic will wear off.
- In *Speed*, the "clock" is the bus's speedometer—if it drops below 50 mph, the bomb will detonate.
- In *Die Hard 2*, the ticking clock is a plane running out of fuel.

In romantic comedies or family dramas, the countdown may involve a wedding, birthday, or baby's birth—as seen in *Bridesmaids* or *Knocked Up*. In *Little Miss Sunshine*, the family rushes to get Olive to the beauty pageant on time, creating a playful ticking clock.

3. The Stakes

For a ticking clock to work, the stakes must be high and meaningful. If failure results in only minor inconveniences, the tension evaporates. However, if failure means severe consequences—such as the death of a loved one or the destruction of a city—the audience will become emotionally invested in the outcome.

For example, in *The Guns of Navarone*, the heroes must destroy two large cannons before Allied rescue ships arrive. Halfway through the mission, they discover that their deadline has been moved up by a full day, increasing the tension further.

4. The Time Limit

Audiences need to know how much time remains—whether minutes, hours, or days. Regular reminders help maintain tension and build toward the climax. In episodic narratives, this can become a structural element.

- In *24*, each episode represents one hour in real-time, keeping the countdown central to the plot.

Shortening deadlines as the story progresses makes the protagonist's task even more difficult, adding to the suspense.

5. When the Time Isn't Precise

Some ticking clocks lack exact time limits but still generate urgency. For example:

- In *Seven*, two detectives race to stop a **serial killer** before he strikes again. While the deadline isn't explicit, the threat of another murder looms constantly, creating tension.

In these cases, the audience stays on edge even without a concrete countdown because they know something terrible could happen at any moment.

6. Obstacles

A ticking clock becomes more effective when the protagonist encounters obstacles along the way. These setbacks create doubt about

whether the hero can meet the deadline. Ideally, the obstacles should intensify as the story progresses. Near the climax, the protagonist's plan should fall apart, increasing the tension even further.

- In *24*, each episode introduces new challenges, making the protagonist's mission harder and more urgent.

7. The Resolution

The protagonist should only succeed at the last possible second to maintain maximum tension. The conflict must escalate as time runs out, ensuring the audience stays engaged. Even if characters momentarily forget the ticking clock, the writer shouldn't—find ways to remind both the audience and the characters of the time constraint.

8. Genre Flexibility

The ticking clock works across genres, from action films to romantic comedies. It doesn't always have to be the story's central conflict—it can also feature in subplots or minor scenes, such as someone rushing to catch a train.

Whether it drives the entire narrative or adds tension to individual moments, the ticking clock is a versatile and powerful tool for keeping audiences engaged.

Red herring

> *The main difference between the exceptionally complicated problem faced by the fictional detective and that of the real detective is that the former usually lacks clues, while the latter has too many.*
>
> —Dashiell Hammett

A red herring is a narrative device used to mislead or divert attention, often to maintain suspense or intrigue. It is especially common in mysteries and thrillers, where false clues are introduced to steer the audience in the wrong direction, making the final twist or revelation more surprising.

For example, in a detective story, a character might exhibit suspicious behavior and appear to have a motive to commit a crime, only for it to be revealed that they are innocent. This character serves as a red herring, shifting suspicion away from the true culprit and maintaining tension throughout the plot.

Historical Origin of the Term Red Herring

The term "red herring" originates from a controversial but widely accepted practice involving **training hunting dogs**. Smoked herrings, with their strong odor and reddish color, were dragged along trails to distract the dogs from tracking the intended scent. This exercise improved the dogs' ability to focus on their target despite distractions.

Over time, the term evolved into a **metaphor** for any form of distraction or misdirection, especially in storytelling or arguments, where it refers to misleading information designed to divert attention from the true issue or solution.

Famous Examples of Red Herrings in Literature and Film

Literature

- **The Hound of the Baskervilles** by Arthur Conan Doyle: In this Sherlock Holmes mystery, multiple characters and situations serve as distractions, leading readers toward incorrect solutions before the true nature of the mystery is revealed.
- **Gone Girl** by Gillian Flynn: The disappearance of Nick Dunne's wife casts suspicion on him, with the narrative deploying several red herrings to manipulate readers' expectations until the final twist.
- **Murder on the Orient Express** by Agatha Christie: Christie, known for her mastery of red herrings, introduces several suspects and misleading clues aboard the train, steering readers down false paths until the truth is uncovered.

Film

- **The Sixth Sense** (1999): Director M. Night Shyamalan uses red herrings to distract the audience from the film's twist ending. Bruce Willis's character appears to lead a normal life, hiding the truth that he is, in fact, dead.
- **The Usual Suspects** (1995): The character of Verbal Kint serves as a red herring, diverting attention from the true identity of the elusive criminal Keyser Söze. The twist reveals that Verbal was Söze all along.
- **Psycho** (1960): Alfred Hitchcock masterfully misleads the audience by initially focusing on Marion Crane, making her seem like the protagonist—only to kill her off early in the film, shifting the plot's direction entirely.

How to Introduce a Red Herring Without It Feeling Forced

Using a red herring effectively requires careful planning to ensure it feels natural and serves the narrative. Here are some strategies to integrate this device seamlessly:

1. Organic Integration into the Plot

The red herring should fit naturally into the story, aligning with the plot's internal logic and the established world. It should not feel like a random addition solely to mislead the audience.

2. Character Development

If the red herring involves a character, their motivations, and actions should be consistent throughout the narrative. They need to behave believably, even if their true motivations are revealed later to be unrelated to the main plot. Avoid one-dimensional characters; instead, create multi-layered individuals with compelling backstories to make the red herring more effective.

3. Foreshadowing and Clues

Subtle hints should be planted throughout the narrative to support the red herring. These details need to feel relevant without being too obvious, so the audience doesn't immediately suspect misdirection.

4. Avoiding Information Overload

Overloading the story with too many false leads can confuse or frustrate the audience. Maintain a balance by giving the red herring just enough focus to be believable without overshadowing the real plot elements.

5. Timing and Revelation

Introduce the red herring at the right moment and reveal its true nature logically. The resolution should provide a new layer of understanding and not leave the audience feeling cheated. When done correctly, exposing the red herring can deepen the narrative.

6. Review and Feedback

Test your plot by seeking feedback from others to ensure the red herring works as intended. Careful review helps confirm that the false clue is well-integrated and functions effectively within the narrative.

A well-executed red herring can elevate a story by increasing suspense and leading the audience through unexpected twists. However, to avoid alienating the audience, it must be carefully crafted and feel organic within the plot. By balancing character development, foreshadowing, and timing, writers can use red herrings to mislead viewers or readers while keeping them engaged until the very end.

Gordian Knot

Ask any fighter: a hammer is just a very heavy lockpicking set.

— The Rant

DM of the Rings #20: "Temple of BOOM"

The term "cutting the Gordian knot" originates from an ancient legend about Alexander the Great. According to the story, a cart in the city of Gordium was tied to a post with a highly complex knot, known as the Gordian knot. A prophecy foretold that whoever could untie the knot would become the ruler of all Asia. Many tried to solve the challenge, but none succeeded.

When Alexander encountered the knot, instead of attempting to untie it in the usual way, he drew his sword and sliced through it in one swift motion. His unconventional approach was accepted as a valid solution, and shortly after, Alexander continued his campaign, eventually conquering much of Asia, symbolically fulfilling the prophecy.

This legend has come to represent lateral thinking—finding an innovative and direct solution to an apparently unsolvable problem. In narrative terms, "cutting the Gordian knot" refers to resolving a complex situation with a simple, decisive action that advances the plot unexpectedly.

Examples of 'Cutting the Gordian Knot' in Film and Literature

Film

- **Raiders of the Lost Ark** (1981): In a famous scene, a swordsman challenges Indiana Jones to what seems like an elaborate duel. Rather than engage in a lengthy fight, Indiana pulls out his gun and shoots the swordsman, ending the conflict instantly. This surprising solution mirrors the concept of cutting the Gordian knot.
- **The Hitchhiker's Guide to the Galaxy** by Douglas Adams: The characters encounter absurd challenges throughout the story. A recurring joke is the unexpected utility of a towel—a seemingly trivial object that turns out to be crucial in bizarre situations. This humorous subversion exemplifies the simplicity of a Gordian solution.

Literature

- **Harry Potter and the Chamber of Secrets** (1998): Harry faces the deadly basilisk in the Chamber of Secrets, a seemingly insurmountable threat. However, Fawkes the phoenix provides the Sword of Gryffindor, allowing Harry to kill the basilisk. This straightforward solution helps resolve a seemingly complex problem.
- **The Lord of the Rings** by J.R.R. Tolkien: Though the journey to destroy the One Ring is arduous, the solution is simple: the

Ring must be thrown into the fires of Mount Doom. Despite the obstacles, the goal remains clear from the start—destroy the Ring to end its power.

Television

- **Doctor Who:** The Doctor frequently resolves complex dilemmas using unexpected solutions, often involving the TARDIS or his sonic screwdriver. These simple but creative resolutions align with the concept of cutting the Gordian knot by bypassing conventional problem-solving methods.

How to Use the Concept of the Gordian Knot in a Screenplay

Plot Development

1. **Establish the Challenge:** Introduce a complicated problem that seems impossible to solve. The complexity of the issue should heighten the audience's curiosity and engagement.
2. **Demonstrate Failed Attempts:** Show characters trying to solve the issue using traditional methods, only to fail. This builds tension and emphasizes the difficulty of the situation.
3. **Deliver a Bold Solution:** Have a character resolve the problem with an unexpected, direct action—cutting the knot instead of untangling it. This solution should align with the character's personality and feel logical within the story.

Character Development

The Gordian knot scenario provides an opportunity to highlight the protagonist's ingenuity or boldness. It can also reveal group dynamics

by showing how other characters react to the solution—some may admire it as brilliant, while others might criticize it as reckless or unethical.

This narrative moment can also serve as a turning point for the protagonist, allowing them to grow or learn a valuable lesson.

Tips for Implementing the Technique

1. **Seek Coherence:** Ensure the solution aligns with the **tone and themes** of your story. It shouldn't feel like a gimmick or a deus ex machina.
2. **Foreshadow the Solution:** Whenever possible, plant subtle hints that suggest a non-traditional solution might emerge. This makes the outcome feel more satisfying and earned.
3. **Consider Long-Term Impact:** Think about how this bold solution will **affect the characters and the story world**. Will it change how the characters approach future challenges? Will it have unintended consequences?
4. **Anticipate Audience Reaction:** Make sure the solution doesn't feel **too easy or convenient**. If handled poorly, it may leave the audience feeling let down. However, if executed well, it can become a memorable moment that stands out in the plot.

The narrative device of "cutting the Gordian knot" offers a way to introduce bold, creative solutions that move the plot forward decisively. It works best when the problem feels complex and insurmountable, and the solution emerges organically from the character's personality or the story's themes. If used thoughtfully, it can generate surprising, impactful moments that engage audiences and highlight character growth. However, writers must ensure that the solution feels consistent and earned, avoiding the pitfalls of seeming like an easy way out.

Red Wedding

Daario: Eso fue rápido.

[limpia el arakh de sangre fresca]

Jorah: Puede que haya otros...

Daario: Lo dudo, los yunkios prefieren dejar que sus esclavos luchen por ellos.

Game of Thrones

The term "Red Wedding" originated from the television series *Game of Thrones*, based on the book series *A Song of Ice and Fire* by George R.R. Martin. It refers specifically to a pivotal event in the third season of the show (and the third book, *A Storm of Swords*), in which several main characters are unexpectedly and brutally killed during a wedding.

As a narrative device, a Red Wedding refers to any moment in a story where the sudden death of key characters dramatically shifts the plot and defies audience expectations. Since its debut, the term has been used to describe similar shocking moments in other series and films. This technique can be effective in keeping audiences engaged, but it is also risky,

as it can alienate viewers who have grown emotionally attached to the characters.

Breaking Traditional Narrative Conventions

The Red Wedding exemplifies *Game of Thrones'* departure from traditional narrative conventions, particularly those typical of the fantasy genre.

In many stories, certain unwritten rules shape audience expectations. For example, protagonists—especially those who are heroic or morally righteous—are often protected from sudden or unjust deaths. Viewers expect some level of justice, with good triumphing over evil and conflicts being resolved satisfyingly.

The Red Wedding defies these conventions. The sudden, senseless deaths of Robb Stark, Catelyn Stark, and Talisa Maegyr feel shocking and unjust. These characters, who in other stories might have been destined to become heroes, are betrayed and killed without any immediate justice or revenge.

Adding to its emotional impact, the massacre takes place during a wedding—an event traditionally associated with celebration, unity, and peace. The inversion of this expectation heightens the shock, making the betrayal feel even more devastating. This moment reflects George R.R. Martin's philosophy: portraying a world that mirrors the cruelty, unpredictability, and moral ambiguity of real life, rather than adhering to the idealized conventions of fantasy.

George R.R. Martin's Explanation

Martin has discussed the Red Wedding in multiple interviews, offering insights into why he chose to include it in the story:

- **Element of Surprise:** Martin wants readers and viewers to feel emotionally invested in the story, and one way to achieve that is by keeping them uncertain about what will happen next. The fear that any character could die at any moment raises the stakes, making the narrative more thrilling.
- **Realism:** Martin strives for a realistic portrayal of war and politics, where even good people can meet tragic ends. In real life, he argues, victories are often incomplete, and justice is not always served.
- **Historical Inspiration:** The Red Wedding was inspired by two real historical events: the Black Dinner (15th-century Scotland) and the St. Bartholomew's Day Massacre (1572 France). Both events involved betrayal and mass killings disguised as acts of peace, mirroring the dynamics of the Red Wedding.
- **Challenging Genre Conventions:** Martin intentionally challenges the clichés of fantasy storytelling, where heroes are typically safe from harm. By killing Robb and Catelyn Stark, he subverts the idea that moral righteousness ensures survival, heightening the unpredictability of the narrative.

Examples of Red Wedding Moments in Film and Television

Psycho (1960)

In *Psycho*, Alfred Hitchcock defies narrative conventions by killing Marion Crane, the apparent protagonist, midway through the film. At the time, audiences were shocked by this twist, as they expected Marion to survive. Much like the Red Wedding, her unexpected death disrupts the plot and leaves viewers uncertain about what will happen next.

Pulp Fiction (1994)

The sudden death of Vincent Vega in *Pulp Fiction* shares similarities with the Red Wedding, as it subverts audience expectations. Vincent is a prominent character, and his death is unexpected. However, there are key differences: Vincent's death mainly impacts his storyline, while the Red Wedding shifts the entire trajectory of *Game of Thrones*. Additionally, because of the film's non-linear narrative, Vincent reappears in later scenes, softening the impact of his death.

Lost (2004-2010)

In *Lost*, Charlie Pace's death is an emotionally powerful moment that surprises both the characters and the audience. Another Red Wedding-like moment occurs in Season 4, when a mercenary attack results in the unexpected deaths of several key characters, altering the group dynamics. Similarly, in Season 5, a mass execution at a communal grave mirrors the brutality and emotional impact of the Red Wedding.

Verano Azul (1981-1982)

The death of Chanquete in the Spanish series *Verano Azul* had a profound emotional impact on audiences across Spain and Latin America. For many viewers, it marked their first encounter with the concept of loss. While different in scale from the Red Wedding, Chanquete's death shares its unpredictability and emotional weight, leaving a lasting impact on the story and its audience.

Characteristics of the Red Wedding as a Narrative Device

When referring to a Red Wedding as a narrative device, several defining characteristics typically apply:

1. Surprise and Shock

The element of shock is essential. While subtle hints or foreshadowing may be present, the event ultimately catches most viewers by surprise.

2. Death of Key Characters

The Red Wedding is memorable for the sudden and violent deaths of central characters, whose loss has significant repercussions for the story.

3. Subversion of Expectations

The Red Wedding subverts traditional narrative conventions by showing that even heroic or morally righteous characters are not immune to tragedy. It challenges the audience's assumptions, leaving them on edge.

4. Long-Lasting Impact

The event has lasting consequences, not just for the plot, but also for the emotional tone of the story. It alters character dynamics and shifts the direction of the narrative.

5. Violence and Brutality

The Red Wedding stands out for its graphic violence, which amplifies the emotional impact of the scene and reinforces the grim, realistic tone of *Game of Thrones*.

Jump the shark

There's an episode of Happy Days where Fonzie literally jumped over a shark on water skis while wearing his signature leather jacket. In the world of TV sitcoms, "jumping

the shark" is now used metaphorically to mark the beginning of the end—the moment when a TV show has passed its prime, and what made it special becomes increasingly hard to recapture. The problem is, you don't realize it at the time: you always feel like you can reignite the magic.

— *Will Smith, in his memoir* Will

The expression "jump the shark" originates from the American TV series *Happy Days*. In its fifth season, in September 1977, with ratings in decline, the series aired the now-iconic scene that gave birth to the phrase. Fonzie, the show's protagonist, visits Los Angeles and, in an unexpected moment, jumps over a shark on water skis to prove his bravery after a bet. This unnecessary and absurd action marked a turning point. Although the series continued for nearly seven more years, many fans felt the magic was gone after this moment.

The phrase was coined in 1985, a year after *Happy Days* ended, when Sean J. Connolly and his friend Jon Hein launched the website *jumptheshark.com*. On the site, they explained the concept:

> "It's a moment. A specific moment when your favorite show has peaked. From that point on, everything goes downhill, and the show will never be the same."

The website invited users to share their opinions about TV shows, but when the domain was sold and redirected to *TV Guide's* homepage, fans

felt betrayed—ironically, saying that the site itself had jumped the shark by diluting its content.

Decalogue to Avoid Jumping the Shark

Since the term *jump the shark* was coined, it has been widely used to describe the decline of a TV show. Below, we analyze common mistakes that lead to such moments and how to avoid them.

1. Don't Change the Protagonist's Essential Physical Trait

Audiences connect deeply with a character's appearance and personality, so drastic changes can feel unsettling—especially when they alter the character's essence. A classic example is Keri Russell in *Felicity*. The show followed a young woman's journey through college, centered around her personal growth and relationships. However, after an emotional breakup, Felicity's decision to cut her signature curly hair alienated fans, and the ratings dropped sharply.

That said, not all physical changes lead to failure. For example, in *Breaking Bad*, Walter White's transformation into Heisenberg—both in appearance and personality—was central to the show's premise. His shift from an ordinary teacher to a dangerous drug lord was narratively justified, enhancing the story rather than undermining it.

2. Don't Resolve the Unresolved Sexual Tension (URST)

URST is a popular narrative device that keeps audiences hooked by delaying romantic fulfillment. Iconic examples include Ross and Rachel

in *Friends* or Mulder and Scully in *The X-Files*. However, resolving this tension prematurely can diminish a show's appeal.

A cautionary tale is *Moonlighting*. The chemistry between Bruce Willis and Cybill Sheppard fueled the show's early success, but when their characters finally became a couple in season three, the spark faded, and so did the series.

Some shows, like *Cheers*, managed to recover. Although Sam Malone and Diane Chambers got together in season two, their subsequent breakup reignited the tension. When Diane left after season five, Kirstie Alley's arrival as Rebecca Howe provided new romantic dynamics that sustained the show until its tenth season.

3. Don't Change the Main Premise of the Show

A show's premise forms the foundation of its narrative. Altering it drastically mid-run can alienate viewers. A prime example is *Prison Break*, which revolved around two brothers—one wrongfully imprisoned, the other devising an elaborate plan to help him escape.

After their escape in season one, the series shifted focus from prisoners to fugitives. Although the show tried to recapture its original premise by re-imprisoning characters in season two, many fans had already lost interest.

4. Don't Write Off a Key Character Without Justification

When main actors leave a series, it's crucial to provide a logical narrative explanation. In *The X-Files*, David Duchovny's departure led to the convoluted storyline of Mulder's abduction by aliens, which hurt the show's credibility despite Robert Patrick joining the cast.

Dallas provides an even more notorious example. After Patrick Duffy left the series, his character Bobby was killed off—only to be resurrected a season later through a dream sequence. This decision permanently damaged the show's credibility. A similar backlash occurred with *Los Serrano*, whose final episode revealed that the entire series had been a dream.

5. Don't Lose the Show's Creator or Lead Writer

The departure of a showrunner can profoundly affect the quality of a series. When Larry David left *Seinfeld* after season seven, fans noticed a decline in the show's comedic edge, even though it remained popular. Creative leadership is often irreplaceable.

6. Don't Drastically Change the Characters' Lifestyles or Status

Abrupt changes in characters' circumstances can feel jarring to audiences. In *Roseanne*, the ninth season saw the Conner family suddenly win the lottery, abandoning the show's working-class premise. This shift alienated long-time viewers, leading to the show's cancellation.

7. Don't Alter the Episode Structure Abruptly

Consistency in structure helps audiences connect with a series. *Lost* initially relied on flashbacks to explore characters' backstories, but the introduction of flashforwards in season three disrupted the narrative flow. While it added intrigue, the complex timeline frustrated some viewers.

8. Don't Experiment Recklessly with Genre

Experimenting with genre can be risky. *Grey's Anatomy* attempted a musical episode that was widely criticized. Characters began singing during a life-threatening emergency, and many fans felt the tonal shift was inappropriate for a medical drama.

9. Don't Overuse Guest Stars and Cameos

While guest appearances can add excitement, overreliance on them can overshadow the main cast. In the final seasons of *Will & Grace*, a string of celebrity cameos—featuring Madonna, Britney Spears, and others—distracted from the core storylines.

10. Don't Overwhelm Characters with Absurd Misfortunes

When a character is subjected to excessive misfortune, it can feel sadistic and alienate viewers. In *ER*, Robert Romano suffered increasingly absurd fates, culminating in his death by falling helicopter debris. While shocking, this excessive treatment frustrated fans of the character.

EPILOGUE

Throughout the pages of this book, I have analyzed 25 narrative devices that writers and screenwriters used to build our stories. We've explored what these tools consist of, how they have been applied in over 150 examples from series and films, and how we can apply them to write our own narratives.

This book can be used as an **emergency manual** to turn to when you're stuck developing the plot of your script. If Chandler's Law suggests introducing someone with a gun when you're stuck with a plot, I'd love for this book to be your gun—the element that unblocks you and helps make your writing more engaging.

To make it easier to use, I've created **25 card**s, one for each resource. You can download them in:

https://cursosdeguion.com/recursos-narrativos-ingles-descargas/

Once the PDF is printed and the cards are cut out, you'll have a deck that you can shuffle, organize, or consult as you write your story. Each card corresponds to a resource, and once selected, you can dive deeper into its usage with the corresponding chapter in the book.

I hope this book is helpful in understanding how some narrative devices are used in storytelling. But don't become too attached to them. Remember that storytelling needs soul and strong characters. These tools can help you structure your plot or invigorate your script, but without a good story to support it, they won't be of much use. Go tackle that blank page, and good luck with your writing!

Index of Movies and Series

24 (FOX 2001-2010)

30 Rock (NBC 2006-2013)

1917 (Sam Mendes 2019)

2001: A Space Odyssey (Stanley Kubrick 1968)

A Nightmare on Elm Street (Wes Craven 1984)

A.I. Artificial Intelligence (Steven Spielberg 2001)

Adaptation (Spike Jonze 2002)

Alf (NBC 1986-1990)

Alfie (Charles Shyer 2004)

Alias (ABC 2001-2006)

American Beauty (Sam Mendes 1999)

Arrested Development (FOX 2006-2019)

Avengers: Endgame (Anthony y Joe Russo 2019)

Avengers: Infinity War (Anthony y Joe Russo 2018)

Awake (NBC 2012)

Back to the Future (Robert Zemeckis 1984)

Being John Malkovich (Spike Jonze 1999)

Big (Penny Marshall 1988)

Big Fish (Tim Burton 2003)

Boston Legal (ABC 2004-2008)

Breaking Bad (AMC 2008-10)

Bridesmaids (Paul Feig 2011)

Buffy the Vampire Slayer (UPN 1997-2003)

Caníbal (Manuel Martín Cuenca 2013)

Cast Away (Robert Zemeckis 2000)

Cheers (NBC 1982-1993)

Click (Frank Coraci 2006)

Coraline (Henry Selick 2009)

CSI: Crime Scene Investigation (CBS 2000-2015)

Dallas (CBS 1978-1991)

Deadpool (Tim Miller 2016)

Der Letzte Mann (F.W. Murnau 1924)

Die Hard with a vengeance (John McTiernan 1995)

Doctor Who (BBC One 1963-Present)

Dora the Explorer (Nickelodeon 2000 - 2014)

Dunkirk (*Dunkerque*) (Christopher Nolan 2017)

E.T., the extra-terrestrial (Steven Spielberg 1982)

El laberinto del fauno (Guillermo del Toro 2006)

El Viaje de Chihiro (Hayao Miyazaki 2001)

ER (NBC 1994-2007)

Everybody Loves Raymond (CBS 1996-2005)

Everything Everywhere All at Once (Daniel Kwan y Daniel Scheinert 2022)

Explota explota (Nacho Álvarez 2020)

Famous, rich and homeless (BBC 2016)

Felicity (WB Television Network 1998-2002)

Ferris Bueller's Day Off (John Hughes 1986)

Fight Club (David Fincher 1999)

Forrest Gump (Robert Zemeckis 1994)

Frasier (NBC 1993-2004)

Funny Games (Michael Haneke 1997)

Battlestar Galactica (ABC 1978-1980)

Game of Thrones (HBO 2011-2019)

Gone Girl (David Fincher 2014)

Gravity (Alfonso Cuarón 2013)

Grey's Anatomy (ABC 2005-Presente)

Happy Days (ABC 1974-1984)

Harry Potter and the Philosopher's Stone (Chris Columbus 2001)

High Fidelity (Stephen Frears 2000)

House of Cards (*Netflix* 2013-2018)

How I Met Your Mother (CBS 2005-2014)

In Treatment (HOT3 2005-2008)

Inception (Christopher Nolan 2010)

Indiana Jones and the Kingdom of the Crystal Skull (Steven Spielberg 2008)

Indiana Jones and the Last Crusade (Steven Spielberg 1989)

Indiana Jones and the Temple of Doom (Steven Spielberg 1984)

Jacob's Ladder (Adrian Lyne 1990)

Jaws (Steven Spielberg 1975)

Jurassic Park (Steven Spielberg 1993)

Kill Bill Vol.1 (Quentin Tarantino 2003)

Knocked Up (Judd Apatow 2007)

La nuit américaine (François Truffaut 1973)

Labyrinth (Jim Henson 1986)

Laurel y Hardy

Le Fabuleux destin d'Amélie Poulain (Jean-Pierre Jeunet 2001)

Les Visiteurs (Jean-Marie Poiré 1993)

Life of Brian (Terry Jones 1979)

Life of Pi (Ang Lee 2012)

Little Miss Sunshine (Jonathan Dayton Valerie Faris 2006)

Lola Rennt (Tom Tykwer 1996)

Los Serrano (Telecinco 2003-2008)

Lost (ABC 2004-2010)

Magnolia (Paul Thomas Anderson 1999)

Malcolm in the Middle (Fox 2000-2006)

Masters of sex (Showtime 2013-2016)

Match Point (Woody Allen 2005)

Matrix (Wachowski 1999)

My Neighbor Totoro (Hayao Miyazaki 1988)

Mission: Impossible (Brian De Palma 1996)

Moonlighting (ABC 1985-1989)

Mork and Mindy (ABC 1978-1982)

My Favorite Martian (CBS 1963-1966)

My Stepmother Is an Alien (Richard Benjamin 1988)

Narcos (Netflix 2015-2017)

No Country for Old Men (Joel Coen y Ethan Coen 2007)

Parasite (Bong Joon-ho 2019)

Perdidos en la Tribu (Cuatro 2009-2012)

Pirates of the Caribbean (Gore Verbinski 2003)

Primal Fear (Gregory Hoblit 1996)

Prison Break (FOX 2009-2017)

Psycho (Alfred Hitchcock 1960)

Pulp Fiction (Quentin Tarantino 1994)

Raiders of the Lost Ark (Steven Spielberg 1981)

Rashōmon (Akira Kurosawa 1950)

Ronin (John Frankenheimer 1998)

Roseanne (ABC 1988-1997)

Saving Private Ryan (Steven Spielberg 1998)

Scary Movie (Keenen Ivory Wayans 2000)

Seven (David Fincher 1995)

Simple Life (FOX 2003-2005) (E! 2006-2007)

Sixteen Candles (John Hughes 1984)

Some like it hot (Billy Wilder 1959)

Spaceballs (Mel Brooks 1987)

Speed (Jan de Bont 1994)

Star Wars: Episode IV - A New Hope (George Lucas 1977)

Star Wars: Episode V - The Empire Strikes Back (Irvin Kershner 1980)

Star Wars: Episode VI - Return of the Jedi (Richard Marquand 1983)

Star Wars: Episode VII - The Force Awakens (J. J. Abrams 2015)

Stranger Things (Netflix 2016-Present)

Superman (Richard Donner 1978)

Tarzan's New York Adventure (Richard Thorpe 1942)

That'll teach 'Em (*Curso del 63/73* in Spain) (Canal 4 2003-2006)

The 39 Steps (Alfred Hitchcock 1935)

The Affair (Showtime 2014-2016)

The Big Short (Adam McKay 20159

The Dark Knight (Christopher Nolan 2008)

The Fresh Prince of Bel-Air (NBC 1990-1992)

The Game (David Fincher 1997)

The Ghostbusters (Ivan Reitman 1984)

The Godfather Part II (Francis Ford Coppola 1974)

The Hunger Games (Gary Ross 2012)

The Lion King (Rob Minkoff y Roger Allers 1994)

The Maltese Falcon (John Huston 1941)

The Martian (Ridley Scott 2015)

The Others (Alejandro Amenábar 2001)

The Perils of Pauline (Louis J. Gasnier y Donald MacKenzie 1914)

The Perks of Being a Wallflower (Stephen Chbosky 2012)

The Phantom (B. Reeves Eason 1943)

The Prestige (Christopher Nolan 2006)

The Princess Bride (Rob Reiner 1987)

The Secret Millionaire (Canal 4 2006-2012)

The Shawshank Redemption (Frank Darabont 1994)

The Silence of the Lambs (Jonathan Demme 1991)

The Simpsons (1989-Present)

The Sixth Sense (M. Night Shyamalan 1999)

The Sopranos (HBO 1999-2007)

The Terminator (James Cameron 1984)

The Truman Show (Peter Weir 1998)

The Usual Suspects (Bryan Singer 1995)

The Walking Dead (AMC 2010-2022)

The X-Files (FOX 1993-2018)

Titanic (James Cameron 1997)

Tootsie (Sydney Pollack 1982)

Toy Story 3 (Lee Unkrich 2010)

Trainspotting (Danny Boyle 1996)

TRON (Steven Lisberger 1982)

Twin Peaks (ABC 1990-2017)

Verano Azul (La 1 1981-1982)

What Women Want (Nancy Meyers 2000)

Whisplash (Damien Chazelle 2014)

Will & Grace (NBC 1998-2017)

Bibliography and Resources

Books

- Balló, Jordi y Pérez, Xavier. *El mundo, un escenario* (Anagrama 2015)
- Booker, Christopher. *The Seven Basic Plots: Why We Tell Stories* (Bloomsbury Continuum 2019)
- Field, Syd. *El libro del guion* (Plot, 1994)
- McKee, Robert. *El guion* (Alba. 2002)
- Piglia, Ricardo. *Tesis del cuento* (Anagrama 1986)
- Seger, Linda. *Cómo convertir un buen guion en un guion excelente* (Rialp 1991)
- Tubau, Daniel. *Las paradojas del guionista* (Alba 2006)
- Tubau, Daniel. *El espectador es el protagonista* (Alba 2015)
- Truffaut, François. *El cine según Alfred Hitchcock* (Alianza Editorial 1990)

Web

- TV Tropes: https://tvtropes.org/
- John August's Blog: https://johnaugust.com/
- Daniel Tubau's Blog: https://www.danieltubau.com
- Javier Meléndez's Blog: https://www.lasolucionelegante.com/
- Bloguionistas's Blog: https://bloguionistas.com/
- Guionnews's Blog: http://www.guionnews.com/
- StudioBinder's Blog: https://www.studiobinder.com/blog/
- Vertele's Blog: https://www.eldiario.es/vertele/
- Fórmula TV's Blog: https://www.formulatv.com/

Lastly

If you have any questions, suggestions, or critiques, feel free to email me at **davidestebancubero@gmail.com.**

You can further explore the concepts discussed in this book through the podcasts and courses available at **cursosdeguion.com.**

Lastly, if you enjoyed this book and found it useful, I would greatly appreciate it if you could share your opinion on Amazon.

Your feedback will help me continue creating books related to the world of screenwriting.

Your support is essential.

I look forward to reading all your comments.

Acknowledgments

I would like to express my gratitude to Ana Busto Campo, Ana Victoria Rodríguez, Gonzalo Tejedor Andrés, Mila Coco, and Silvana Camors for their help in reviewing this text. Their valuable comments and suggestions have greatly contributed to improving this work.

Thanks also to the listeners of the *Guiones y guionistas* podcast, who accompany me on this journey into screenwriting, of which this book is just another step, and to the subscribers of the *cursosdeguion.com* platform, whose support makes this project possible.

www.ingramcontent.com/pod-product-compliance
Lightning Source LLC
Chambersburg PA
CBHW071455220526
45472CB00003B/811